ARTEFFECTS

ARTEFFECTS

Jean Drysdale Green

WATSON-GUPTILL PUBLICATIONS/NEW YORK

Photography: Terrace Photography, Victor France

Art on front cover by Pegi de Angelis

Copyright © 1993 Jean Drysdale Green

First published in 1993 in the United States
by Watson-Guptill Publications,
a division of BPI Communications, Inc.,
770 Broadway, New York, N.Y. 10003

Library of Congress Cataloging-in-Publication Data

Green, Jean Drysdale, 1931-
 Arteffects / Jean Drysdale Green.
 p. cm.
 Includes index.
 ISBN 0-8230-2529-2 : (pbk.)
 1. Art—Technique. 2. Artists' materials. I. Title.
N7430.G677 1993
 702'.8—dc20 93-26799
 CIP

Manufactured in Hong Kong

7 8 9 10/ 04 03 02 01 00

TO ADVENTUROUS ARTISTS

ACKNOWLEDGMENTS

To my many friends who have contributed their time, creativity, and work to this book, I thank you.

To my husband, Ron, whose total support I can always count on.

To Keith Bollen for the motivation to write this book.

To Marian Appellof for her skill and professionalism in the planning and editing of this book.

CONTENTS

INTRODUCTION

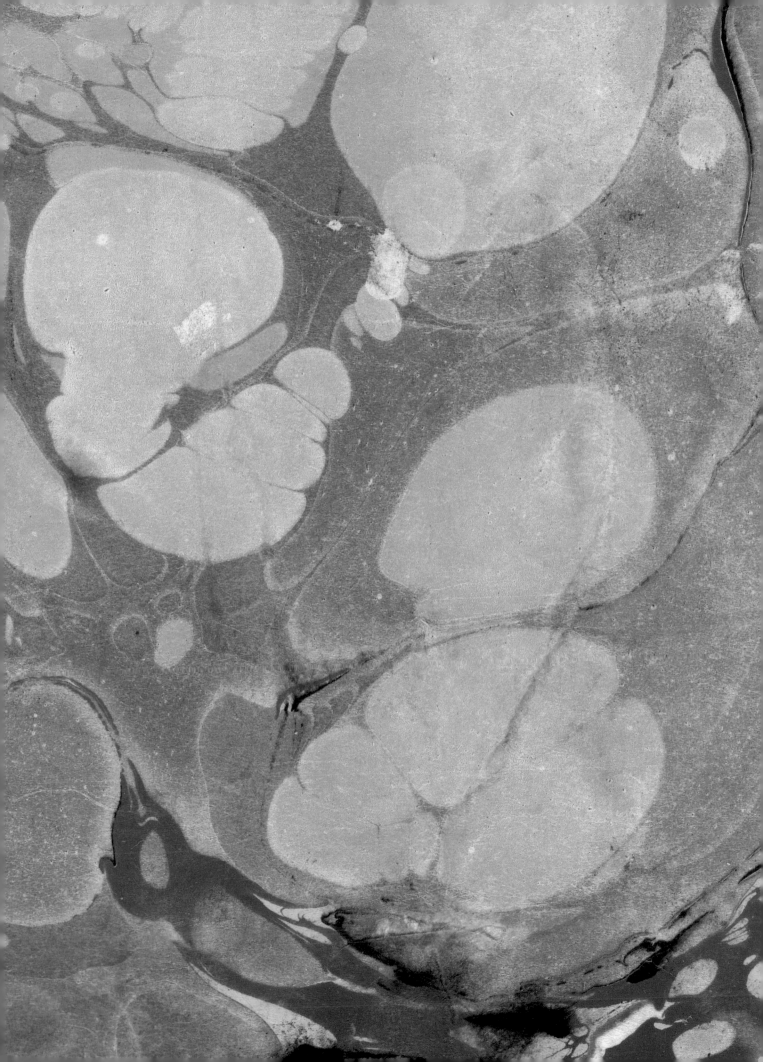

I am not a prolific painter, and being a partner in a busy art supply store for the past seven years left me little time to paint. What I did get from the store, however, was the opportunity to work with just about every product on the market. From paints to papers and brushes, nothing was left untried. Hence this book, which comprises many of the experiments I and my fellow artists have made—experiments I hope you will try in the spirit of expanding your own creative ideas.

More often than not when I start a painting, I have absolutely nothing in mind as to how it will look when it is finished. I usually start by dripping or pouring watercolor or ink onto a sheet of paper and moving the colors around until I see something that excites me. As any watercolorist will tell you, watching shapes form and colors merge is an exhilarating experience. I would like to emphasize that this delight in the act of creating can be as important to me as a finished painting.

Another way I gain inspiration is to go gliding with my son. If I could only recapture the natural beauty and symmetry of the landscape as it looks from three thousand feet above the earth, I would be somewhere near my goal of matching my aesthetic achievement with my creative ambition. This eternal shortfall between achievement and ambition is, on the one hand, a major source of frustration and, on the other hand, a powerful motivating force that keeps me striving forever optimistically. It is one of the best ways I know to put myself in touch with nature both visually and mentally, and in some respects is a form of meditation.

So come and take this journey of serendipity with me—a journey on which you'll make happy and unexpected discoveries by accident. I think this is what my book is all about.

It is wonderful to have your own studio to paint in, or just to get away to and sit quietly, surrounded by art books and interesting objects. I love collecting bits and pieces to add atmosphere to my studio and to use as reference material—old bottles, dried flowers, hats, a sheep skull, and a mannequin are just a few of the items I have assembled. A special feature of my studio is a stained glass window I had made that incorporates the artist's color wheel. An absolute rainbow when caught by the sun, it is also a practical reference of color relationships, for I can see at a glance the complementary colors, split complementaries, and triads when the need arises. All in all, the atmosphere of such surroundings is very conducive to painting.

As a mixed-media painter, I use a wide variety of art and art-related materials. Here I outline only the very basics of what I generally work with. Naturally, what you use will depend on your choice of medium. I do not think there should be hard and fast rules laid down about paper and other materials, as each artist is different.

PAPER

I always use high-quality paper; my favorites are Waterford rag and Bockingford watercolor papers, both of which can take a lot of punishment with the varied materials I use on them. I find that the 140-lb. (300 gsm) weight suits most of my needs,

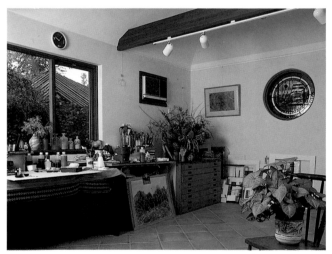

A view of my studio. Note the stained glass window at right.

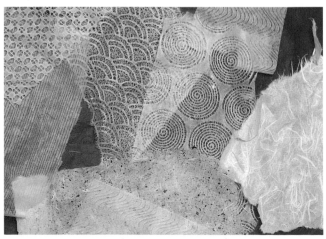

I love working with variously textured Japanese papers like these, especially for collaging.

although I sometimes like to use heavy watercolor board. The paper surface I prefer to work on is hot-pressed (smooth), though I sometimes also use cold-pressed (medium-textured) and rough papers. For collaging, acid-free tissue paper works well, and you can easily tint it with acrylic colors.

I really enjoy using Japanese papers, which are very versatile and are now readily available. After attending a papermaking workshop in Japan and witnessing the effort that goes into making these papers, I now treat them with a lot more respect. The particular kind I made was Washi paper, which is produced from kozo fiber. A great deal of satisfaction is derived from first making your own paper and then collaging it to your painting. Besides Washi paper, with its beautiful long fibers, I sometimes use lovely lace papers or Chiri paper, which is speckled with bark from the kozo plant.

Palette and brushes. The wide, flat, wooden-handled brushes are Japanese hakes.

PALETTE

The palette I use for watercolor and acrylic paints has sixteen wells surrounding a large central area for mixing my colors. Along one side are holes that can hold nine brushes. The palette is fitted with a lid to keep the colors moist while not in use. When I work with water-based or solvent-based inks, I simply use them straight from the bottle.

Whether I use these different mediums alone or in combination, I usually work with two reds, two blues, and two yellows of each. One color in each pair is warm, the other cool. Typical warm/cool pairings are cadmium red and alizarin crimson, ultramarine blue and Prussian blue, and cadmium yellow and lemon yellow. For the beginner these colors are adequate, as you can mix all your secondary colors—purples, oranges, and greens—from these. Other colors that are favorites of mine and are useful to have on your palette are raw sienna, burnt sienna, and Payne's gray.

BRUSHES

I have a large assortment of brushes and use whichever ones suit my needs for a particular painting. I work with everything from a 4-inch Japanese hake brush to a variety of smaller brushes including long, narrow riggers, bullet-shaped, pointed rounds, square-headed flats, and round-headed filberts. When traveling, I keep my brushes

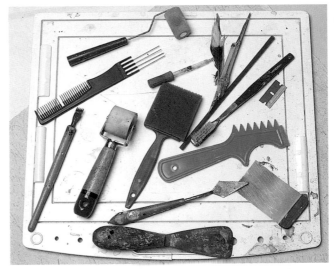

I use a wide variety of tools in my painting—palette knives, feathers, sponges, toothbrushes, combs, and more.

in a bamboo mat threaded with thin elastic. This makes them easy to carry and allows air to circulate, keeping wet brushes from mildewing.

TOOLS

When choosing tools to use in painting, you are limited only by your imagination. I haunt hardware stores for unusual things I can use to make marks, gouge, scrape, sponge, or scratch out parts of a painting. Palette knives, sponges, bird feathers, toothbrushes, bamboo sticks, tissues, razor blades, spray bottles, masking fluid, salt, eyedroppers, combs, drinking straws, and rubber rollers (brayers) are just some of the items I use to create textures and other effects in my work.

INKS

Liquid inks have been in use since ancient times. The first known type was India ink, a black drawing ink made of pure carbon pigment and said to have been invented by the Chinese some four thousand years ago. Today, artists have a wealth of inks in a rainbow of colors to choose from, and are likely to use them not just in the traditional ways—for writing and drawing—but in unconventional ways as well. Inks can be combined with other mediums, applied to a variety of surfaces, and used in a wide range of techniques. Some inks can be used like watercolors for beautiful transparent effects; other inks, combined with, for example, metallic spray paint, yield exciting color passages that can stand alone as abstract paintings or be incorporated into other works.

For our purposes, inks divide into two categories: water-based and solvent-based. (The thicker, pastelike inks used in printmaking processes such as etching and lithography are not included here.) I encourage you to experiment with many different inks and materials, but before using any of them in a work of art you intend to last, become familiar with how well they will stand the test of time. Only materials that are designated as archival-quality can ensure longevity and relative stability. Also pay attention to an ink's rating for lightfastness (resistance to fading and color change when exposed to light) and permanence (resistance to fading and color change when washed).

■■ WATER-BASED INKS

Water-based inks are made of dyes or pigments suspended in water, with a binder such as glue, shellac, or gum arabic added to the solution. Inks containing a varnish such as shellac or an acrylic binder are waterproof. Nonwaterproof inks are made with a binder that will liquefy when dried ink is rewet. The term *drawing ink* is a broad one, encompassing India inks and colored drawing inks regardless of whether they are pigment- or dye-based, waterproof or nonwaterproof, transparent or opaque. Also included are products known as liquid watercolors and liquid acrylic colors.

In general, inks made with pigments have a higher degree of lightfastness than inks made with dyes, which tend to be fugitive—meaning that they fade quickly when exposed to light. Nonlightfast drawing inks are generally made with dyes and are

intended for design and illustration work that is to be reproduced in print, not for works of fine art that are meant to last. Formulated especially for designers and graphic artists, these inks are favored for their brilliance and transparency. They can be diluted with water and mixed together to create new colors and are excellent for airbrush work, as they can be washed out very easily. Dr. Ph. Martin's Radiant Concentrated Water Color, Koh-I-Noor Rapidograph Universal Transparent Colored Drawing Ink, FW Nonclogging Waterproof Drawing Ink, Luma Brilliant Concentrated Water Colors, and Holbein Drawing Ink are just a few examples.

India ink is an opaque black ink made with permanent, lightfast carbon pigment. Both waterproof and nonwaterproof India inks are available. White inks and metallic inks are also pigment-based and opaque, and may be waterproof or nonwaterproof. Popular brands include Higgins, Holbein, Koh-I-Noor, Dr. Ph. Martin's, Pelikan, Rowney, Speedball, and Winsor & Newton.

Related to India ink but in solid form are Chinese and Japanese ink sticks (the Japanese name for this ink is sumi), which are made with carbon pigment (usually pine soot or lampblack) and hide glue. The ink stick is rubbed in water against a stone dish to soften it for use. Depending on how much water you use, you can achieve tones that range from deep, dense blacks to the palest of grays.

Acrylic-based inks (or liquid acrylics), made with pigments and an acrylic binder, are fast-drying, waterproof, and suitable for fine art. Both transparent and opaque colors are available, and can be mixed to create new hues. Transparent colors can be thinned with water for watercolor and glazing effects (although once dry, cannot be lifted like watercolor paint), or mixed with white or black acrylic ink to attain opaque effects. Acrylic-based inks can be used on a wide range of surfaces, including paper, illustration board, metal, wood, glass, acetate, plastic, and fabric, and can be applied with dip pens, technical pens, paintbrushes, and airbrushes. Popular brands include Dr. Ph. Martin's Spectralite, Perma Draft, and Tech inks; Rotring Artist Color; and Winsor & Newton Designers Liquid Acrylic Colour.

Inks that are meant to be used in fountain pens (including calligraphy fountain pens) are sometimes made with dyes and are often nonwaterproof so that they will flow freely and won't clog the pen. Inks meant for technical pens, which are used chiefly in

precision work such as drafting and illustration, are most often required to be waterproof, opaque, and permanent, though transparent and glossy inks are also available, as are inks specially formulated for use on drafting film and acetate. Characteristics vary greatly from brand to brand, however, so always read product labels. Many technical pen inks can also be applied with a dip pen, brush, or airbrush, but they should never be used in fountain pens.

Available from Rotring are *effect mediums*, liquid, acrylic-based metallic inks that come in gold, silver, copper, bronze, and pearl. These inks can be mixed with other inks to give shimmering effects.

Relatively new to the market are water-based enamel inks, designed for such crafts applications as china painting without kiln firing and for creating stained glass effects. Durable and opaque, they are glossy when dry and can be applied to wood, metal, glass, plastic, and acetate, as well as paper. These inks are nonfading and waterproof. Colors can be mixed and applied like acrylic or watercolor paint with a soft brush. Two brands are Deka-Translucent and Vitrail Ceramic à Froid.

▓▓ SOLVENT-BASED INKS

Solvent-based inks, generally sold as "stained glass colors," are used with solvents other than water, such as mineral spirits or acetone, depending on the brand. Noted for translucent and intense color, they were originally designed to be used on glass or acetate to create stained glass effects, but I have adapted them for fine-art applications as well.

To take advantage of the luminosity of solvent-based inks, you must apply them to a support with a very slick, shiny surface they can "sit" on, such as glossy paper or illustration board. Another excellent surface to try is melamine, a plastic that is often used for shelving or cupboards. When applied to matte surfaces, solvent-based inks tend to lose their luminous quality because they sink into the paper—although you may like this effect.

Use solvent-based inks only in a well-ventilated room. It is a good idea to rub a little barrier cream into your hands before working so that they do not get stained. The brushes I use to apply these inks are made of nylon or another synthetic (natural hoghair bristles can cause streaking with these inks). After use, wash brushes first in mineral spirits, then with a little detergent and warm water.

Solvent-based inks dry completely within eight hours, but are dry to the touch in about one hour.

The solvent-based inks I work with are called Couleurs Vitrail and are made by Pebeo, a French manufacturer; another brand on the market is Deka-Transparent, made by Decart Inc. Both makers also provide a paste (called "outline paste" or "outline relief") that can be squeezed onto a painting to imitate the leading in a stained glass window.

MATERIALS, TOOLS, AND TECHNIQUES TO TRY WITH INKS

WITH WATER-BASED INKS:
- acrylic matte and gloss varnishes
- acrylic gel medium
- gouache
- metallic effect mediums
- mineral spirits
- masking fluid
- Japanese papers
- waxed paper
- plastic wrap
- nonstick cooking spray
- dishwashing detergent
- string
- sand
- silk
- marbling
- monoprinting
- sun painting

WITH SOLVENT-BASED INKS:
- outline paste
- mineral spirits
- acrylic modeling paste
- acrylic paint
- spray paint
- metallic effect mediums
- masking fluid
- oil pastels
- wax crayons
- water-based inks
- plastic wrap
- wallpaper paste
- sand
- marbling

WATER-BASED INKS

Various water-based inks can be used for marbling, monoprinting, and in all sorts of other imaginative ways to create beautiful and unusual effects. Some inks are particularly well suited to more traditional applications, such as pen-and-wash techniques; others are excellent for airbrush work. The examples that follow are just a sampling of the possibilities.

▬▬ PAPER FOLDING

To create these effects, I folded sheets of Japanese paper and dipped the corners in colored inks, then carefully unfolded the paper right away to reveal the patterns you see here. (The Japanese paper I use for this technique soaks up the ink quickly.) I then placed each sheet on newsprint to dry. By folding the paper in different ways, you can obtain a variety of interesting, attractive patterns. Any water-based inks will work; if you want paler effects, dilute the colors with water. To get a two-tone effect, wait for the first ink application to dry, refold the paper, and redip the edges in ink.

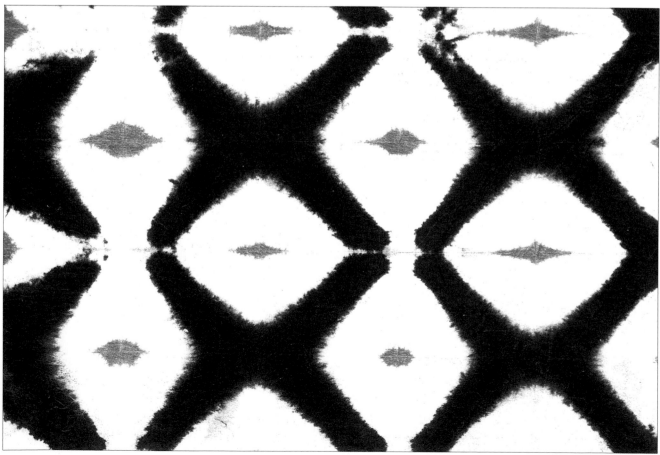

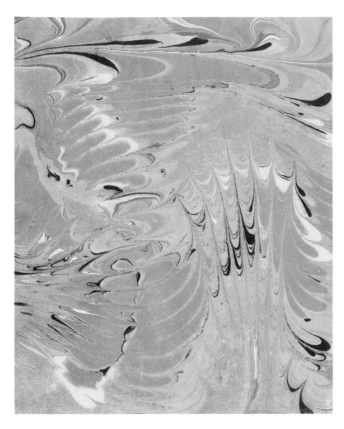

▬ *MARBLING*

The marbling technique is hundreds of years old; it is thought to have originated in Japan with the *suminagashi* process and then spread to Persia and Turkey. I've found that wallpaper paste is a quick and easy substitute for the carrageenan that is normally used in marbling. To make the examples shown here, I mixed powdered wallpaper paste with enough water to make a runny, jellylike solution and half-filled a foil baking dish with this mixture. Then, with an eyedropper, I dropped various colored inks (Art Spectrum, Rotring, and Steig are brands I often use) onto the surface of the paste, where they float but don't mix. I combed into the mix with a feather to create an interesting pattern, then placed a sheet of paper on top, leaving it just long enough—about thirty seconds—for the ink to take. I lifted off the paper carefully and ran it under the tap to remove excess paste and ink, then left it to dry on a sheet of newsprint. You can use any good-quality paper for marbling; in general, a lightweight paper is best. To place your paper on top of the paste, hold it by opposite corners and gently lower it down.

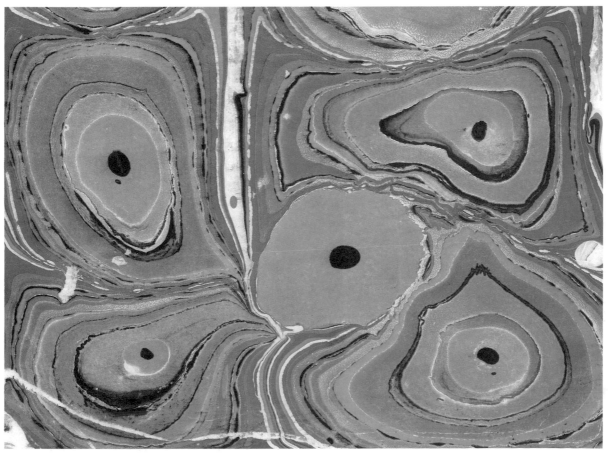

WATER-BASED INKS

▇▇ SUN PAINTING

This simple technique was shown to me by the artist Maxine Masterfield when she visited Australia to conduct workshops. (You can learn more about it in her book *In Harmony with Nature*, published by Watson-Guptill.) For each of these examples, I first sprayed the paper (smooth watercolor paper works very well here) with water and, while it was still wet, dripped and poured inks onto it. I then placed an object on top of the inked paper and left it to dry in the sun. When the liquid evaporated, an impression of the object was left on the paper.

This example bears the impression of a shell.

Pattern left by Japanese lace paper.

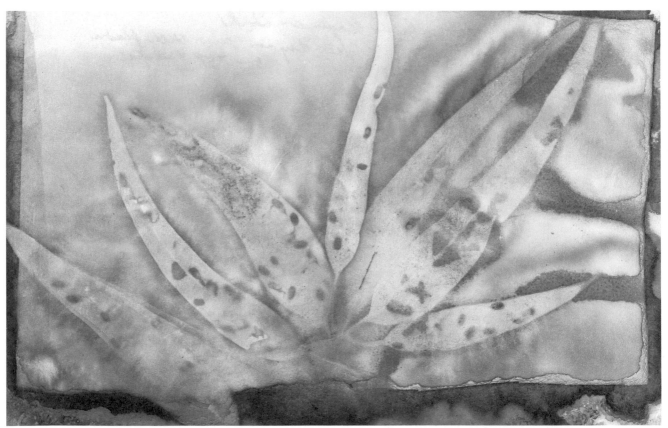

Sun painting made with gum leaves.

CREATING HARD-EDGED SHAPES

In this variation on the sun-painting technique (right), I cut a shape out of an old X-ray film and placed it on a sheet of watercolor paper covered with a wet ink wash, then left it to dry. Wherever the edges of the film came in contact with the ink, they left sharp, distinct lines. Old X-ray films are quite good to use as templates.

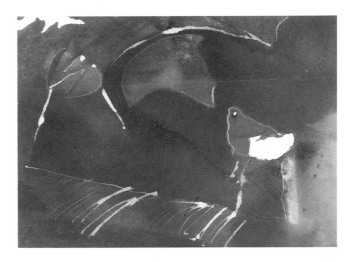

MONOPRINTING WITH CORNSTARCH

To make the monoprint shown below, I made a cornstarch paste and mixed it with my inks, then painted the colored mixtures on a sheet of glass. I placed a sheet of dry paper over the coated glass surface, pressing it down to pick up color, and then carefully lifted it off the glass. The suction created by the starch paste results in an exaggerated pattern in the print. This effect lends itself to depicting rocks, caves, and underwater scenes. Using this technique on damp paper results in softer edges.

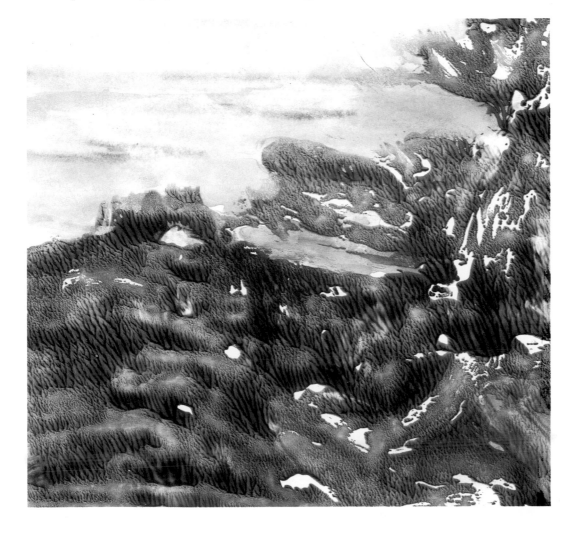

WATER-BASED INKS

■■■ TEXTURING WITH PLASTIC WRAP

Many shapes and patterns can be obtained by placing plastic wrap (such as Saran Wrap) over a wet ink wash and leaving it there until your paper is dry. Removing the plastic reveals texture, which you can then work back into if desired. In example A (right), I put the ink on my paper first and then covered it with plastic wrap, aiming to control its placement so as to achieve a figural image. For B (below), I laid several washes of ink on watercolor paper and covered it with plastic wrap, pulling the plastic horizontally to create a pattern resembling opal seams. In C (below right), I added trees to the textured background to create a landscape.

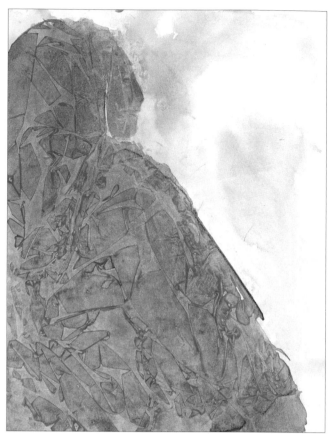

A.

B.

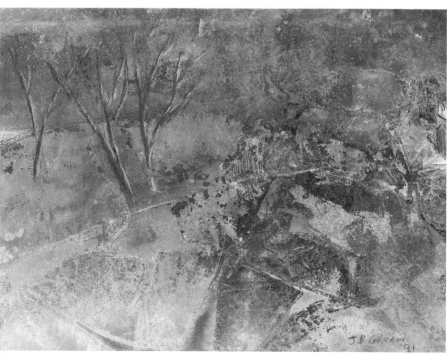

C.

◼◼ TEXTURING WITH WAXED PAPER

To create the textural effects at right, I dropped ink diluted with water onto watercolor paper and covered it with waxed paper while it was still wet. When all was dry, I removed the waxed paper to reveal the patterns you see here. Note how some of the wax settled into the ink to form a resist. This method is excellent for depicting rocks and texture on buildings.

◼◼ MICROWAVING FOR TEXTURE

I decided to see what the microwave oven could do. I placed two colors of ink (in this case the brand I used was Art Spectrum) on my paper, dropped on a piece of plastic wrap, and set the microwave on high power for sixty seconds. As you can see below, the patterning that resulted is more pronounced than in preceding examples, and the mottling effect was an added bonus.

WATER-BASED INKS

■ USING NONSTICK SPRAY AS A RESIST

Here, I sprayed onto watercolor paper a substance
used in cooking to keep food from sticking to
utensils, and discovered that it works as a resist to
inks. In the example at left, I used the spray first,
then added ink. In the one at right, I put down a
wash of ink first, then sprayed.

■ EXPERIMENTING WITH DISHWASHING LIQUID

I dropped dishwashing liquid into an ink wash,
creating a pattern.

■ CREATING PATTERNS WITH STRING

Dropping string into a wet ink wash lets you form
many patterns. I usually put a weight on top to
hold the string firmly in place until the paper is dry.

TRYING BLEACH ON INK

Simply as a matter of curiosity, I decided to see what effect bleach would have on ink. (I do not recommend using bleach in serious works of art.) In the first example at left, I used an ordinary fountain-pen writing ink (most of which are dye-based) and dropped in some household bleach. Note that the blue ink turned a burnt sienna color. In the second example, I used a blue acrylic-based ink, which was also radically affected by the bleach.

Bleach on fountain-pen writing ink.

FREEZING INK ON PAPER

Japanese paper was used in the experiment shown below. I floated several ink washes onto the paper's surface and put it in the freezer, leaving it overnight. The next morning, after removing the ice from the paper, I was left with this lovely patterning. Note in particular the white bubbles in the left-hand corner.

Bleach on acrylic-based ink.

WATER-BASED INKS

▬▬ CREATING SHAPES WITH MINERAL SPIRITS
Using a brush, I flicked mineral spirits onto a wet ink wash to create spots and shapes. You can also draw lines with the brush. The mineral spirits tends to push the ink color aside.

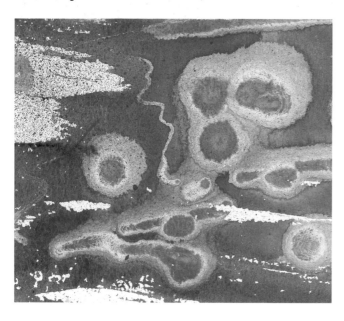

▬▬ APPLYING ACRYLIC MATTE VARNISH
These subtle patterns were obtained by dropping acrylic matte varnish into wet ink.

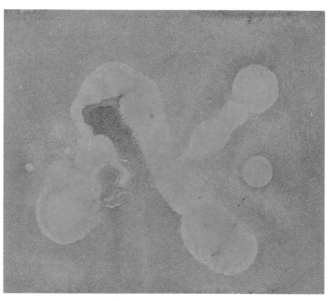

▬▬ APPLYING ACRYLIC GLOSS VARNISH
Dropping acrylic gloss varnish into wet ink tends to push the ink aside to create spots. It also leaves the ink with a glossy look.

▬▬ APPLYING ACRYLIC GEL MEDIUM
When applied fairly thickly, acrylic gel medium can give you impasto effects. Here, gel medium placed on a wet ink wash resulted in slightly raised ridges. Ink collected around the raised areas, creating shadowy shapes.

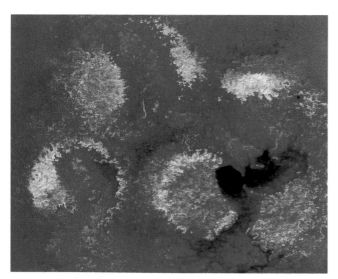

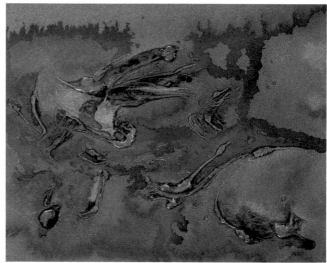

ADDING GOUACHE TO INK

To create the effect shown at top right, I laid a wash of ink on watercolor paper and, while it was still wet, dropped in some white gouache. Note the bleeding marks that resulted. This effect would work well in a seascape painting.

WORKING WITH MASKING FLUID

Masking fluid, made of liquid latex, is used to mask off areas of a painting where you don't want color to go. After applying it to your painting surface, let it dry. Then you can apply ink right over it. Once the ink is dry, remove the masking fluid simply by rubbing it with your finger. Masking fluid can be applied with a brush; you can also deposit a puddle of it on your paper and blow on it through a straw to move it around, as in the example below. Another useful tool is a ruling pen, which lets you create fine lines like the ones that represent the birds and grasses in the example at right. Try masking fluid on colored paper for some interesting effects, too.

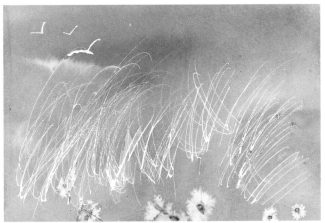

Masking fluid applied with a ruling pen.

Masking fluid used on colored paper.

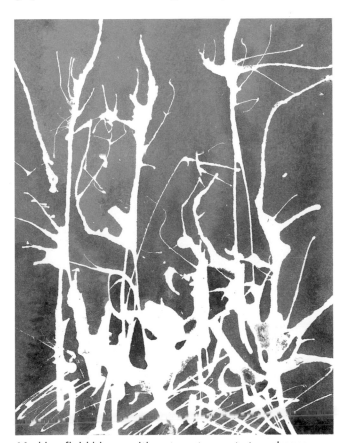

Masking fluid blown with a straw to create tree shapes.

WATER-BASED INKS

■■■■ USING EFFECT MEDIUMS

Effect mediums (metallic acrylic-based inks) can add a great metallic look to your paintings. You can either mix the medium directly with other water-based inks, or lay down a wash of ink first and, while it is still wet, drop effect medium into it. The swatches at the top of this page show how red, yellow, and blue inks look by themselves and when mixed on the palette with pearl effect medium. In the example that follows, pearl effect medium was dropped into a wash of red ink applied to etching paper, resulting in a strong linear quality.

Inks with and without pearl effect medium mixed in.

Pearl effect medium dropped into a wet wash on etching paper.

Copper effect medium dropped into a wet wash.

Copper effect medium dropped into a black wash.

Pearl effect medium dropped into a variegated wet wash.

Silver effect medium dropped into a variegated wet wash.

Copper effect medium dropped into a variegated wet wash.

WATER-BASED INKS

■ WORKING WITH FELT-TIP PEN AND WASH

For pen and wash drawings, you need to use an ink that is waterproof so that when washes are applied over the pen work, the ink will stay put. For this example (left) I used a Sakura felt-tip drawing pen, which comes in different sizes (here, .04) and contains waterproof, pigmented ink that is said to be lightfast. I blocked in the trees first, then wet the paper and, with a brush, added the colored ink washes. After the washes were dry, I added the shrubs with my felt-tip pen.

■ INCORPORATING SAND WITH PEN AND WASH

After deciding where I wanted sand texture in my painting (right), I brushed acrylic matte medium (which acts as an adhesive) in the appropriate area on dry watercolor paper. While the acrylic medium was still wet, I sifted on clean sand and let the area dry. Next, I applied colored acrylic ink washes, and when these were dry, I drew in the vegetation with a Sakura felt-tip drawing pen.

■ AIRBRUSHING WITH INKS

Many different kinds of inks can be used with an airbrush, as long as they won't clog the apparatus. Besides its widespread use in graphic art and illustration (as well as in creating designs on T-shirts), the airbrush has many fine art applications. The technique described here is surprisingly simple, yet the results are dramatic. The secret is to use a low-tack, clear plastic masking film called frisket to create hard edges, which help give forms a very realistic look. These are the steps artist Keith Bollen followed to create the airbrushed illustrations shown at right:

1. Draw (or trace) the leg, including the outline of the stocking top, on a sheet of masking film and adhere the film to smooth illustration board.
2. Cut the leg shape out of the film with a scalpel or X-Acto knife and put it aside, as you will reuse it later.
3. With the airbrush, spray on ink in a flesh color using alternately light and heavy applications to create the illusion of three-dimensional volume.
4. Replace the lower leg and upper thigh portions of the masking film, leaving only the stocking top section exposed.
5. Spray the stocking top with black ink, again using light and dark applications to model form.
6. Remove the lower leg section of the mask and spray this area with black ink, this time using a much lighter application than you did for the stocking top but again modulating the amount to model form.

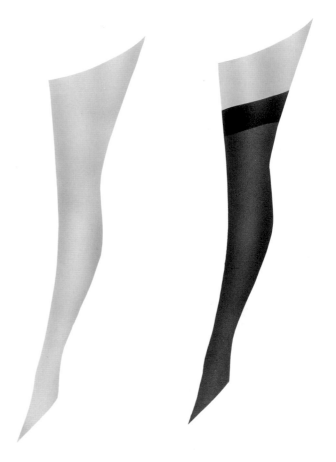

■ HAND-COLORING PHOTOGRAPHS

I used acrylic-based inks—Rotring Artist Color, in this case—to hand-color the black-and-white photograph at right. In more skillful hands, better results than those seen here can be obtained.

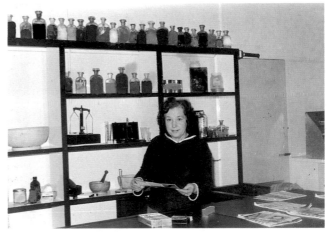

WATER-BASED INKS

■ MARBLING SILK WITH ACRYLIC INKS

To marble this piece of silk (right), I used Rotring Artist Color inks, which are acrylic-based. I filled a baking dish three quarters of the way with water (the size of the fabric you're marbling will determine the size of the container you use) and dropped in the inks. Because they are acrylic-based, they float on the water's surface long enough to let you move them around with a skewer to form a marble pattern. Next, I carefully laid the silk on the water's surface and left it there for a few seconds to pick up the ink. (You can see the pattern as it comes through the back of the silk.) I then removed the silk and put it aside for about fifteen minutes to dry. To seal the colors into the fabric, I ironed it between two sheets of paper.

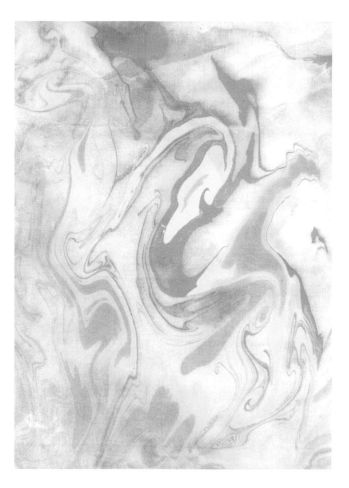

■ PAINTING WITH JAPANESE INK STICKS

Japanese ink sticks are ink in dry form that you rub with water against a stone dish made of slate or lava to liquefy for use. The examples shown below were done on rice paper, which you can purchase in rolls. The delicate blacks and grays you see here are Japanese ink applied with a brush; the pink flowers and green leaves were rendered in watercolor. For some interesting textures, you can wet the end of an ink stick and draw with it.

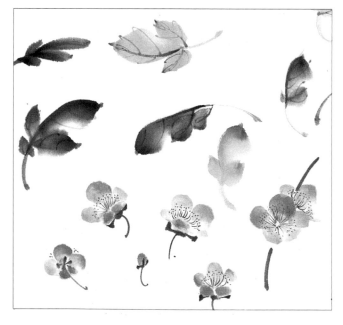

■ *TRYING OUT WATER-BASED ENAMEL INKS*

These nonfading, waterproof inks are relatively new on the market. They do much of what solvent-based inks do, but are opaque rather than translucent. They dry glossy, and can be applied to wood, metal, glass, plastic, acetate, and paper. An imitation-lead outline paste is also available for use with these inks. You can mix colors and apply them with a brush the way you would acrylics or watercolor. Here I've tried them on a sheet of clear acetate, which emphasizes their glossy finish. The other example was done on a piece of watercolor board; note how the colors look when thinned with water, and how when more thickly applied they retain their glossy character.

Water based enamel inks on acetate.

Water-based enamel inks on watercolor board.

DEMONSTRATION: WATER-BASED INKS

▬ USED IN BATIK

Batik is a wax-resist technique traditionally used for creating designs on fabric. Here, I demonstrate a variation on this method, using wax as a resist to water-based acrylic inks applied to paper. In preparation, I stretch a piece of 140-lb. Waterford hot-pressed watercolor paper and tape it to my drawing board.

As shown at right, I begin by drawing my composition—a fish design—on the paper with a 2B pencil. Next, I melt a lump of beeswax and pour it into a tjanting, a pointed metal tool used in the traditional batik process.

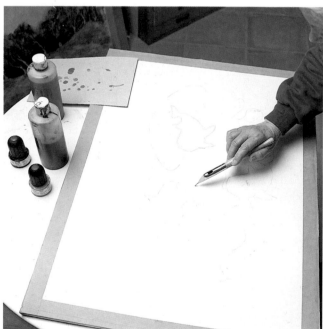

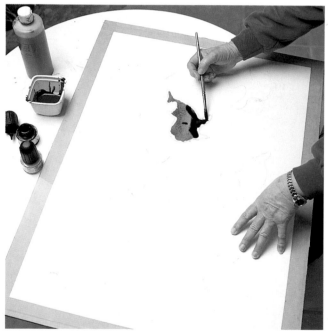

Using the tjanting, I now trace the outlines of the fish with the melted beeswax, making sure to join up all the lines in the design. This has to be done fairly quickly before the wax in the tool solidifies and has to be remelted. I usually keep the wax hot by having an electric frypan handy. Once I finish outlining the fish, I draw other lines randomly with the wax. Wherever I want larger white shapes to appear in the painting, I apply the wax more thickly.

Next, with a round watercolor brush, I apply color to the fish, starting with ultramarine blue and adding a little black to give roundness to the forms.

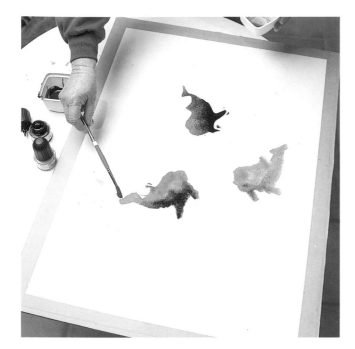

I continue working this way with other colors until all the outlined spaces are filled. In most cases the ink will be contained within these shapes, but sometimes the color flows over areas where the wax lines do not join. Don't worry about this, though; the effect can actually enhance the painting. When the painting is completely dry, I scrape off the wax with a credit card. I've found that this tool doesn't dig into or tear holes in the paper. Try this variation on the batik technique on colored paper as well.

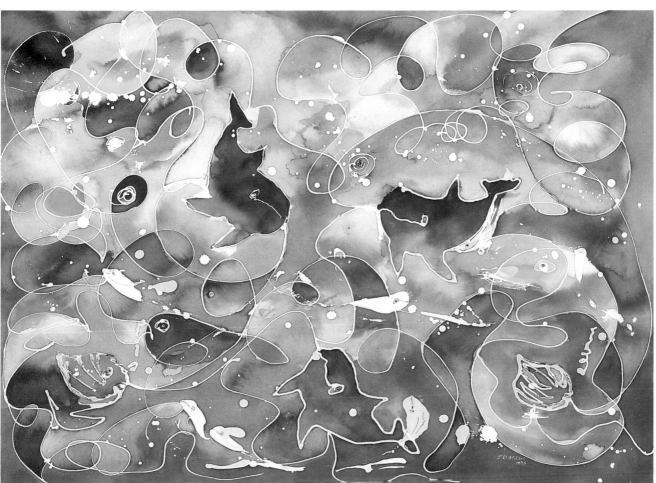

Jean Drysdale Green, *Fish Fantasy*, acrylic ink on paper, 22 × 30" (55.9 × 76.2 cm).

SOLVENT-BASED INKS

Of all the inks I use, these are my favorites because of their wonderful luminous quality. I have even written a book about them titled *Five Minute Flower Painting* (Sydney, N.S.W.: Australian Artist Magazine, 1992). Solvent-based inks were originally designed for use in creating stained glass effects, but I have discovered that, used with imagination, they permit many other beautiful and exciting effects that can be incorporated into works of fine art.

WORKING ON A SLICK SURFACE

Applying solvent-based inks to a glossy surface exploits their rich, translucent color, as these swatches (top right) on very slick card show.

IMITATING A STAINED GLASS WINDOW

The design of the work at bottom right was taken from a stained glass pattern book by Ed Sibbett, Jr., titled *Art Deco* (New York: Dover). I first traced the woman's face on a sheet of acetate using outline paste, which imitates the leading in stained glass windows. The paste comes in a tube with a very fine nozzle that permits linear work. When the paste was completely dry, I added the inks with a brush, keeping the colors within the areas defined by the outline paste.

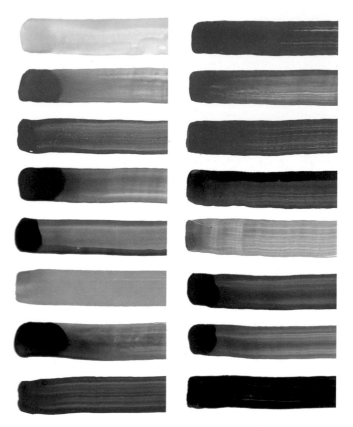

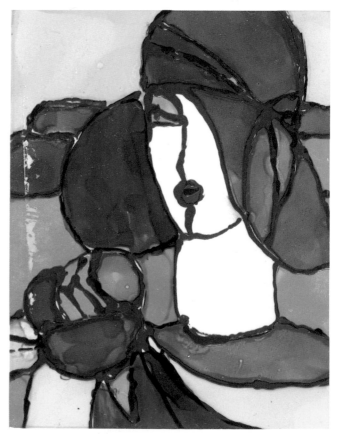

■ MIXING SOLVENT- AND WATER-BASED INKS

I obtained the interesting effect at right by combining solvent-based inks and water-based inks (here, Rotring Artist Color) on paper. Because one of the inks is water-based and the other solvent-based, they resist each other.

■ PAINTING ON COPPER SHEETING

Solvent-based inks adhere well to thin copper sheeting, as shown below at left; they can also be used to decorate small jewelry items such as earrings that are sold as "blanks" in crafts stores.

■ EXPERIMENTING WITH MINERAL SPIRITS

The effect at bottom right was achieved by adding mineral spirits to the ink with a brush or dropper. Mineral spirits dilutes the color's intensity and moves the ink around. I obtained the muted colors by using some of the mineral spirits I washed my brushes in.

SOLVENT-BASED INKS

▬▬▬ TEXTURING WITH PLASTIC WRAP
In the example at right, I applied inks to paper and placed a sheet of plastic wrap over the surface while it was still wet. I let it dry, then removed the plastic wrap to reveal these wonderful treelike patterns.

▬▬▬ CREATING IMPASTO EFFECTS
To get the lovely, almost metallic-looking impasto effect shown below, I applied acrylic modeling paste to the paper using a palette knife and, when it was dry, applied solvent-based inks over it straight from the bottle.

ADDING SAND FOR TEXTURE

Sand is wonderful for adding textural interest to a painting. Here, in the example at right, I first applied some acrylic modeling paste in a wavelike pattern, then sprinkled on sand. The modeling paste acts as an adhesive (acrylic gel medium also works). When this was dry, I painted over the sand with blue and green inks, which gave me a lovely marine effect. It's great to watch the ink sink into the sand.

RECYCLING OLD POSTCARDS

Using solvent-based inks, artist Lachie Drummond painted the little picture of Australian Christmas trees shown below on an old postcard with a shiny surface, leaving parts of the image printed on the card to show through. To capture the intense orange color of the trees' flowers, she used acrylic paint in an opaque manner. This is a good way to use up your unwanted postcards.

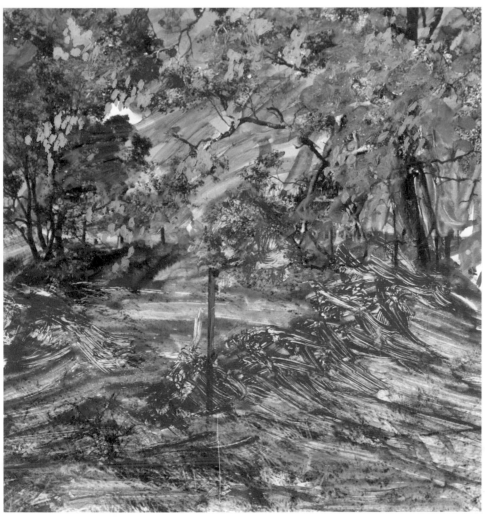

SOLVENT-BASED INKS

▬▬ MARBLING WITH SOLVENT-BASED INKS

To get marbled effects, I filled a small baking tray with water and dripped inks onto the water's surface, moved them into a pattern with a skewer, then placed a piece of paper on top to pick up color. You must move these inks quickly, as they tend to "set" on the water. Different paper surfaces can give different results; one of these examples was done on drawing paper, the other on Japanese paper.

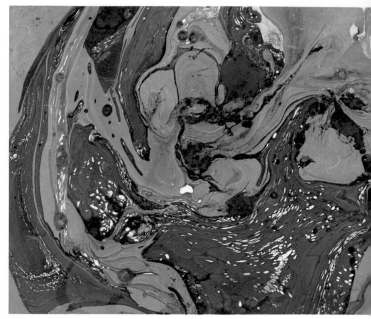

Marbling on drawing paper.

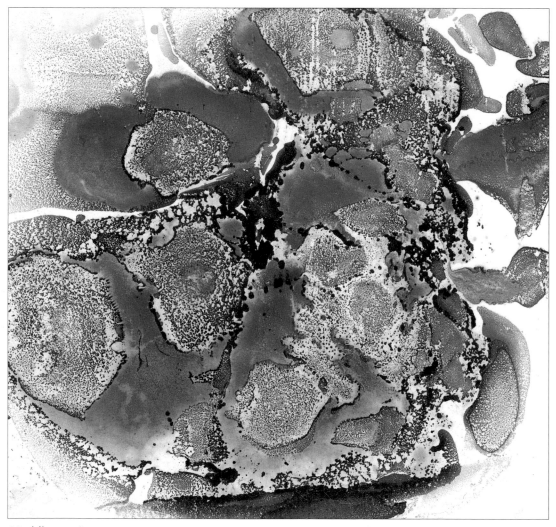

Marbling on Japanese paper.

EXPERIMENTING WITH THICKENER MEDIUM

In the example at left, I used the inks in combination with a product made by Pebeo called "thickener medium." This colorless substance dilutes the inks but does not alter the intensity of their color.

TEXTURING WITH WALLPAPER PASTE

I mixed up a batch of wallpaper paste to a jellylike consistency and poured it into a small baking tray. I then dropped ("floated") solvent-based inks onto the paste with a dropper and very quickly placed a piece of glossy card face down on top of it just for a few seconds to pick up color. This very textured effect resulted; the bubbles were caused by the paste.

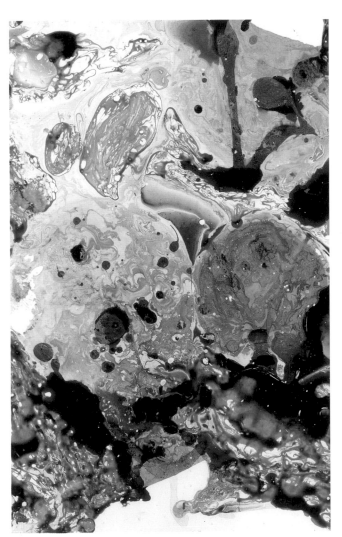

SOLVENT-BASED INKS

▬▬ COMPOSING A PAINTING

Working on smooth (hot-pressed) illustration board, I began this painting by blocking in the flower arrangement using inks diluted with mineral spirits, keeping in mind that I wanted my focal point to be the bottom yellow flower. When the surface was dry, I dropped in more color, sometimes with a brush and sometimes using an eyedropper. These inks have a mind of their own and spread quickly, the colors merging and flowing at will; I sometimes move my painting surface from side to side to hasten this process. While this application of ink was still wet, I dropped in more ink, which formed lovely rings, similar to the effect created by dropping a pebble in water. By adding colorless thickener medium (made by Pebeo) to the ink, I was able to achieve slightly thicker rings.

Generally, you can keep working with solvent-based inks for about an hour, depending on how hot or cold the weather is. Keep handy a strip of the same paper you are working on as a place to test colors before you apply them to your painting surface. When I want washes or glazes, I mix my inks with mineral spirits in small glass jars to thin them. I also keep some of the mineral spirits that I wash my brushes in to use as a background wash, which can yield some subtle color effects. To create a mottled effect, I spray mineral spirits onto ink that is still wet. For spattered texture, I flick ink onto a painting with a toothbrush.

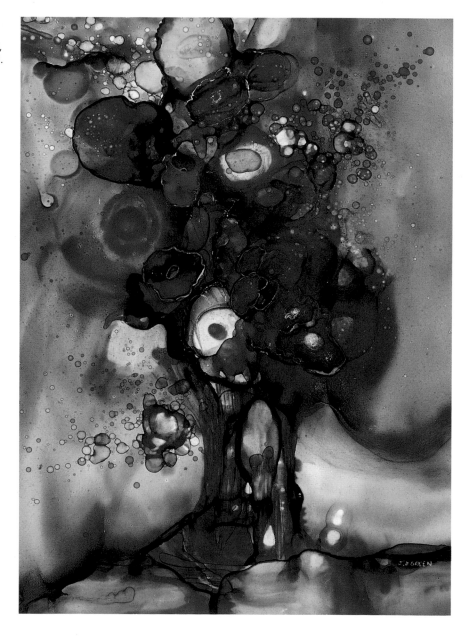

Jean Drysdale Green, *Bouquet,* solvent-based ink on illustration board, 22 × 15" (55.9 × 38.1 cm).

▮▮▮ USING MASKING FLUID

I flicked masking fluid here and there onto my painting surface and, when it was dry, applied the inks. When the inks were dry, I removed the masking fluid to uncover a lovely white speckled effect.

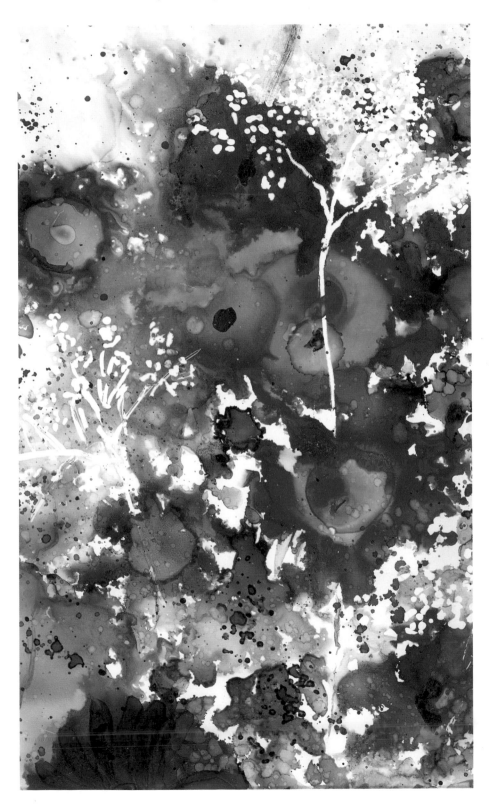

SOLVENT-BASED INKS

■■■ ADDING INTEREST WITH OIL PASTELS

Oil pastels let you incorporate interesting linear elements in a painting and work very well with solvent-based inks, as this example shows. Here, in the example at left, I applied the ink first and then the oil pastel. It is possible to do the opposite— apply ink over the oil pastel—but because the ink is solvent-based, it tends to dissolve the pastel.

■■■ USING WAX CRAYON AS A RESIST

Wax crayons make it easy to introduce graphic effects in your ink paintings. In the example at right, wax crayon was applied to the paper first, then inks applied over it. The crayon resists the ink.

 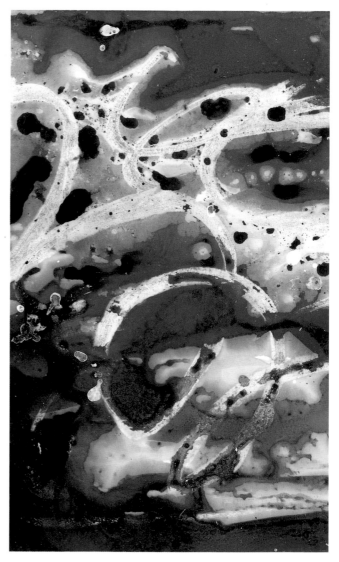

■■■ USING WAX CRAYON ... 'NERAL SPIRITS

In the example at left, I drew on my painting surface with colored wax crayons, creating a resist for the inks I then applied over these marks. Next, I flicked on mineral spirits to achieve a spotting effect.

■■■ TRYING A SILVER WAX CRAYON

I applied silver wax crayon to my painting surface first to establish a subtle metallic effect, then added inks. The silvery speckled effect resulted from the inks dissolving some of the crayon.

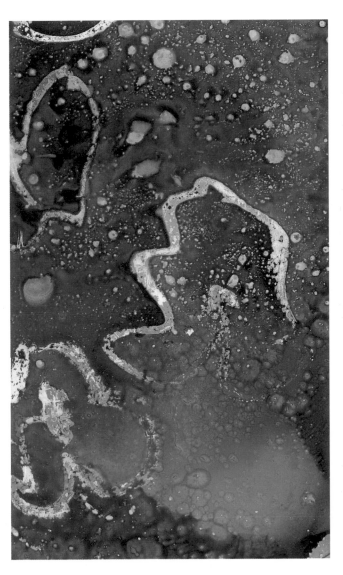

SOLVENT-BASED INKS

■■■ APPLYING METALLIC SPRAY PAINT

Many of the spray paints commonly sold in hardware stores and even supermarkets are solvent-based, and so combine well with solvent-based inks. To create the two examples shown here, I floated a fair amount of ink onto my paper with a 1-inch brush, then applied silver spray paint to one and gold spray paint to the other. Note the effect of the heavier paint application in the gold example.

 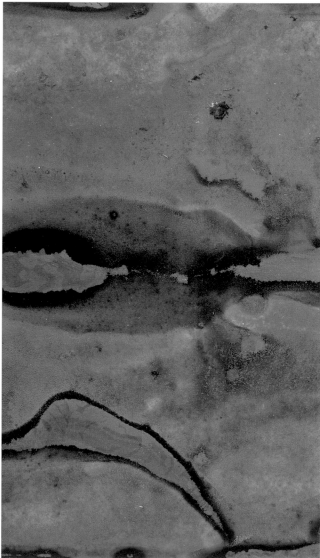

▰ MIXING IN EFFECT MEDIUM

I squirted pearl and copper effect mediums (water-soluble, acrylic-based metallic inks) onto a surface to which I had applied solvent-based inks; the combination resulted in the dramatic-looking piece at left.

▰ USING SPRAY PAINT AND EFFECT MEDIUM

To get the effect shown below, I first applied inks to my painting surface and, while it was still wet, used a red spray paint. I then squirted on some gold effect medium. Wonderful textures resulted.

WATERCOLOR
AND
GOUACHE

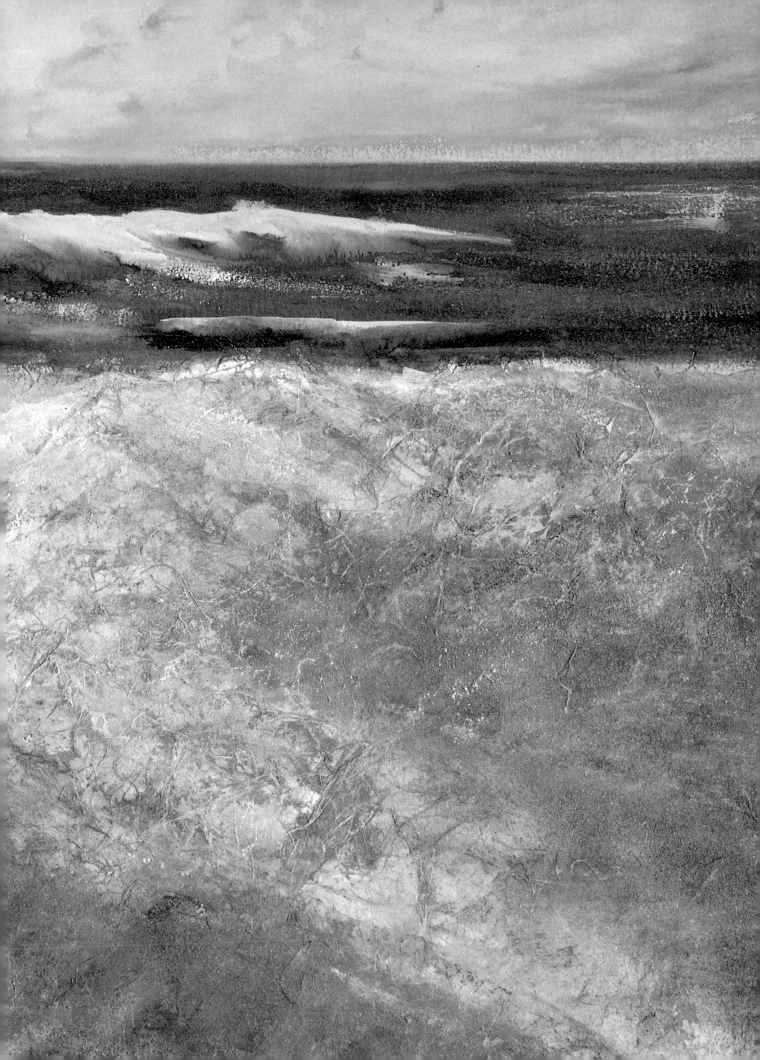

Watercolor painting, sometimes described as one of the more delicate arts, dates back to prehistoric times, with evidence of water-based paintings from the Stone Age appearing in the caves of Lascaux and Altamira. Watercolor attained real prominence in the eighteenth and nineteenth centuries, particularly in the hands of the British artist J. M. W. Turner, who boldly explored the technical and expressive possibilities of this medium. Watercolor painting quickly became prized for its freshness and spontaneity.

Today, watercolor is divided into two categories, transparent and opaque. Generally, the term *watercolor* refers to transparent colors, while the opaque paints are known as *gouache*.

TRANSPARENT WATERCOLOR

Transparent watercolors are made of pigment, gum arabic, and a wetting agent, usually glycerin. They are available in tubes, which contain semimoist paint, or in pans, which contain dry cakes of paint that dissolve readily in water. The main characteristic of this medium is its transparency, allowing the white of the paper or a previous layer of color to show through. By tradition it is applied in washes that, when laid one over another, permit subtle variations of tone and color. Much has been written about traditional transparent watercolor techniques, and I will review some of these, but I would like to show you other ways watercolor can be used, particularly in combination with other mediums and materials that make it possible to achieve some vigorous effects and textures.

Perhaps one of the best things about watercolor is that with the exception of a few colors that stain, it can all be removed from your painting surface so you can start over again or use the back of the paper. When I have messed up both the front and the back of a watercolor painting, I often use it as collage material. So take a bold approach to your paintings and have a go. After all, it is only a sheet of paper!

GOUACHE

Gouache (possibly from the Italian word *guazzo*) is made like transparent watercolor but contains additives that make it opaque and slower-drying.

This medium has long been favored by designers and graphic artists for its wonderful covering power, but it has been enjoying increasing favor among fine artists for the flawless plains of dense, matte color it permits. Good-quality gouaches have great tinting strength, and with a few exceptions, these paints have a high degree of permanence. They are wonderful when used on colored papers and can be extremely attractive on black paper. Gouache is also handy when you want to cover a mistake in a transparent watercolor painting.

PAPER

A good-quality, acid-free rag paper, preferably the 140-lb. (300 gsm) weight or heavier, is most suitable for watercolor work, and both sides of the sheet may be used. There are three basic watercolor paper surfaces: rough, which as the name suggests has prominent peaks and valleys (known as "tooth") and is great for stressing texture; cold-pressed, which is less textured and is by far the most popular support for watercolor painting; and hot-pressed, which is very smooth and thus ideal for ink and line work.

Any paper that is suitable for watercolor is also suitable for gouache. Some of the colored papers used for pastel (such as Canson Mi-Teintes) are also very nice to use because of their opaqueness. Of course, these papers, like any other lightweight paper, must be stretched before you paint on them or else they will buckle.

MEDIUMS AND AUXILIARY PRODUCTS

Various mediums and paint-related products can be used in conjunction with watercolor paints to alter the way they perform according to your needs and to extend the range of effects you can achieve with them. (Additional materials are listed below.)

- *Gum arabic,* an extract of a species of the acacia tree, is the binder used in watercolor paints. It can be diluted with water to make a weak solution that when added to watercolors increases their depth, transparency, and gloss.
- *Aquapasto,* made by Winsor & Newton, is a gel composed of gum arabic and silica that can be mixed with water-based paints to achieve impasto effects.

- *Ox gall* is a wetting agent that enhances the flow of watercolor and improves its acceptance on less absorbent surfaces. It will not increase the transparency of your paints, and should be used only in small amounts. Another agent for improving the flow of watercolor is Winsor & Newton's *Water Colour Medium,* a solution of acidified gum and water that should not be used with acid-sensitive pigments (such as cadmium yellow).

- *Glycerin* retards the drying of watercolor by slowing down the evaporation of water. It is especially useful when you need to keep an area of a painting wet for longer than usual, but should be used only in very small amounts, since nowadays most commercially prepared watercolor paints already contain a fairly high proportion of glycerin.

- *Prepared Size,* made by Winsor & Newton, is a glue composed of gelatin, water, and preservative and supplied as a soft gel that becomes liquid when warmed. Its purpose is to reduce the absorbency of certain grounds, including paper, boards, and lightweight textiles. If you wish to use decorative and unusual papers for watercolor, prepare the surface with size first to prevent too much absorbency and bleeding of colors.

- *Masking fluid,* also called liquid frisket, is essentially a liquid latex preparation that is used to block out areas of work where you do not want paint to go. Some masking fluids are colorless; others are pigmented for better visibility. Apply masking fluid only to dry surfaces. To remove, simply rub it off with your finger.

MATERIALS, TOOLS, AND TECHNIQUES TO TRY WITH WATERCOLOR AND GOUACHE

- flat and graded washes
- blending
- drybrush
- blotting
- wet-in-wet
- acrylic modeling paste
- acrylic gloss and matte mediums
- gesso
- metallic effect mediums
- water-based printing ink
- mineral spirits
- turpentine
- Liquin
- wallpaper paste
- hydrogen peroxide
- dishwashing liquid
- plastic wrap
- cellophane
- Japanese papers
- tissue paper
- waxed paper
- wax crayon
- candle wax
- rice
- salt
- eggshells
- leaves
- seashells
- seaweed
- sand
- sandpaper
- sponges
- polystyrene
- fiberglass
- lead pencil
- charcoal
- watercolor pencils
- china markers
- sgraffito
- razor blade
- stenciling
- spattering
- collage
- monoprinting
- airbrush
- stitching

WATERCOLOR AND GOUACHE

Watercolor and gouache lend themselves to creating a wide variety of effects, from traditional transparent washes to interestingly textured monoprints. In most of the examples in this chapter, it would not have mattered whether I used gouache or watercolor except where a transparent look was required.

■■■ LAYING A FLAT WATERCOLOR WASH

A good flat watercolor wash should be all one tone like the example at top right. Dampen your paper before starting so that no hard lines form. Mix up more paint than you think you need and, with your drawing board slightly tilted, fill your brush with color and apply the first strip across the top of the paper. Reload the brush and, working in the opposite direction, repeat the process. Continue until you have covered the entire area. Any drips of paint at the end of the page can be picked up with a clean, damp brush squeezed of excess water.

■■■ LAYING A GRADED WASH

As illustrated at right, a graded wash shows a progressive variation in tone. It is invaluable for painting convincing skies. Mix up a puddle of paint on your palette. Dampen your paper with clean water. Tilt your drawing board, then load your brush with color and stroke it along the top of the paper. Rinse out your brush and add a brushful of clean water to your paint mixture. Stroke this slightly lighter color on the paper. Again rinse your brush, add a brushful of clean water to the paint mixture on your palette, then stroke the progressively lighter color on your paper. Repeat this procedure until you get to the end of your page, where the color should be lightest.

■■■ MAINTAINING A SHARP EDGE

To lay a soft wash against an edge that needs to remain crisp and precise, first draw the outline with a 2B pencil, then dampen your paper up to the line and work paint into just the dampened area. (It is possible to use a clean, damp brush instead of a pencil to draw this outline.)

▰▰ *BLENDING COLORS*

To get the blended effect shown at left, dampen a sheet of watercolor paper. Lay in a strip of color to either side of the center of the paper. Then, in the center, lay in another color. The colors will bleed into each other to give a variegated effect. This is useful when you want to incorporate distant trees into a wet sky. In general with watercolor, work on dry paper when you want sharp lines and on damp paper when you want softer edges.

▰▰ *USING THE DRYBRUSH TECHNIQUE*

This technique is favored for depicting grass and other textures, although if used too often can look gimmicky. For the example shown below, I dipped a fan brush into paint, then wiped some of the color off with a paper towel. I then pulled the "dry" brush across my dry watercolor paper. More of the white paper shows through when you apply less pressure to the brush.

WATERCOLOR AND GOUACHE

■ RESERVING WHITES

In traditional transparent watercolor technique, the white areas of a painting, such as clouds, are represented by the white of the paper. Reserving whites means painting around them. To create the cloud study at top right, I dipped my brush in clean water and used it to outline the cloud shapes, leaving their interiors dry. I then dampened the rest of the paper surrounding their forms and dropped in color. The paint will go only where the paper is wet. Any hard lines that may appear can be softened with a damp brush and blotted with a tissue.

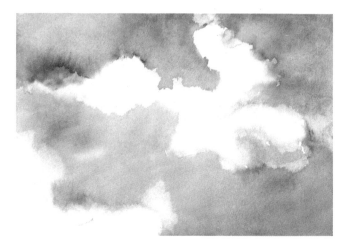

■ BLOTTING

In the example at center right, I applied color to dampened paper and, while the surface was still damp, blotted out the shape of the clouds with a tissue. You could also use a sponge to do this.

■ USING GOUACHE

Below, I applied color to the paper and, while it was still wet, dropped in white gouache, which bled into the other colors and resulted in these cloudlike effects.

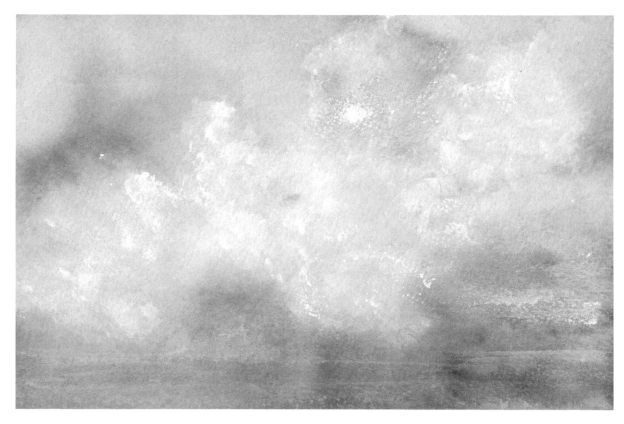

...OITING THE TEXTURE OF ROUGH PAPER

...ffect seen at right, I simply dragged
a b...ed with color across a sheet of rough
wate...per. The paint sits on top of this
paper's ...mpy "peaks" and doesn't entirely sink
into its "valleys," where the white shows through.

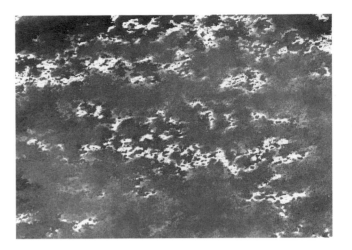

▬▬ PAINTING WET-IN-WET

Applying paint to wet paper causes colors to blur
softly, resulting in beautiful, often unpredictable
patterns like those seen below. Painting wet-in-wet
is the most exciting way to do skies. Simply lay in
a wet wash and drop color into it. Alternatively,
dampen your paper with clean water and apply
paint while the surface is still wet. Move the paper
around and let the colors mix and mingle to get
some lovely effects.

WATERCOLOR AND GOUACHE

◼◼◼ EXPERIMENTING WITH AQUADHERE

Artist Carole Ayres chose very heavy watercolor paper as the support for this painting. She began by running lines of Aquadhere, a waterproof woodwork glue, across the surface to suggest the contours of hills in a landscape, then let it dry. Next, she wet the paper and dropped in color, allowing the paint to flow freely. When the paper was dry, she collaged on abstract tree shapes of black crinkled rice paper and patterned Japanese paper, and established two moon shapes with pieces of stained canvas, gluing everything on with Aquadhere. Ayres added the silver work in the final stage with a felt-tip calligraphy pen; similar results can be achieved with silver paint or ink applied with a brush. Ayres went over the glue five times with her pen, allowing the ink to dry between coats.

◼◼◼ SOFTENING COLOR WITH GLYCERIN

Glycerin extends the drying time of watercolor paints, making it possible to achieve soft-edged color fusions like those you see below. Artist Peter Walker created this example by painting a mixture of one part water and one part glycerin over the surface of his paper, then dropped in all his colors at once. Glycerin also makes it easier to wash color off a painting and to wipe back—remove color with a tissue to reveal the white paper.

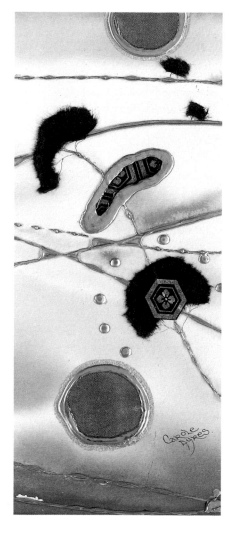

Carole Ayres, *Abstract Landscape*, watercolor, collage, Aquadhere, and silver ink on watercolor paper, 11½ × 5" (29.2 × 12.7 cm).

CREATING FINE LINES WITH WAXED PAPER

For these fine linear effects at right, I put a piece of waxed paper over dry watercolor paper and, with a sharp stick (a ball-point pen would also work), drew a pattern of lines I wished to remain white. I then applied a watercolor wash. The wax from the waxed paper created a resist that prevented the paint from filling in my drawing.

WORKING WITH MASKING FLUID

Masking fluid lets you mask out areas of work needing protection when color is applied in broad washes. In this painting, artist Rona Harrison applied the fluid with a ruling pen to mask out the lines that now appear as white. She then applied washes of color, and while these were still wet, dropped in mineral spirits to give the mottled effect. Once the painting was dry, the masking fluid was removed.

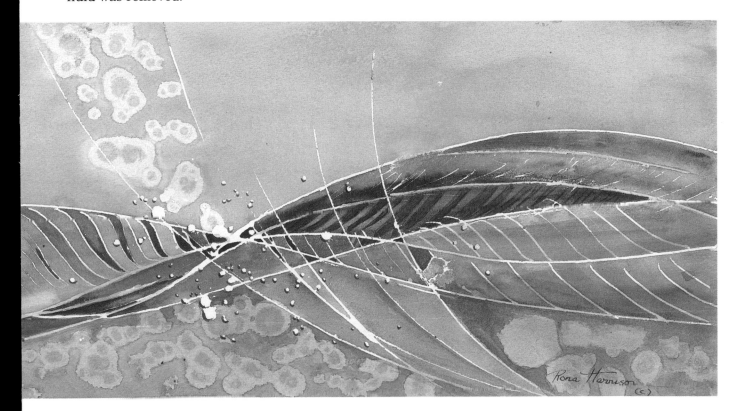

WATERCOLOR AND GOUACHE

■■■ IRONING ON WAXED PAPER FOR TEXTURE

To get the effect at top right, first I crumpled up a piece of waxed paper and placed it on my watercolor paper. With a moderately hot iron, I then pressed the waxed paper, depositing some of the wax on the watercolor paper to act as a resist for a subsequent wash of color. The pattern that results with this technique resembles the texture of rocks and coral.

■■■ RUBBING WITH A WAX CRAYON

To simulate bark texture as shown at center right, I pressed my paper against a tree trunk and rubbed over it with a black wax crayon. By controlling where I applied the crayon, I defined the shapes of two trees while literally recording their texture. I then applied watercolor over the rubbing, the crayon acting as a resist.

■■■ RUBBING WITH A WAX CANDLE

For the example below, I placed my paper against the same tree and rubbed it with a candle to record the underlying bark texture, then applied a wash of watercolor over it. Seen on the horizontal, the resulting textural effect lends itself to depicting rocks or surf.

USING TURPENTINE AS A RESIST

Although more commonly used as a solvent for oil paints, turpentine acts as a resist when used with watercolor. I created the example at left by painting a shape on my paper in turpentine, then applying a watercolor wash over it. The droplets and streaks you see came about because watercolor and turpentine do not mix.

USING LIQUIN AS A RESIST

Liquin, made by Winsor & Newton, is a medium used to thin oil and alkyd paints and speed their drying. Used with watercolor, however, it acts as a resist, pushing color around, and can result in some quite exciting effects. In the example shown below, I put down a watercolor wash first and, while it was still wet, painted the lizard with a brush dipped in Liquin.

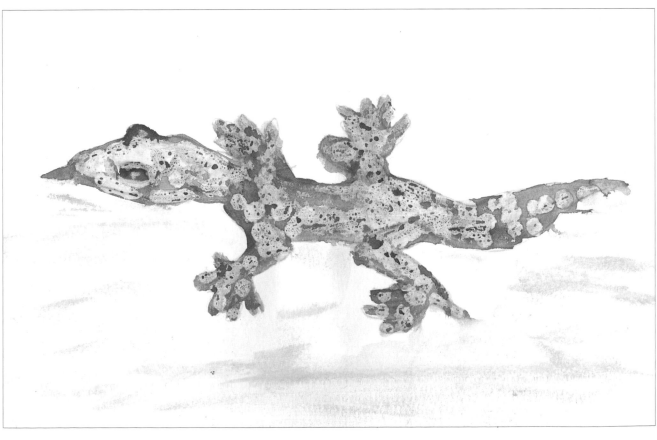

WATERCOLOR AND GOUACHE

■ TEXTURING WITH RICE

To get the effect shown below, I laid a watercolor wash on my paper and, while it was still wet, dropped on some rice and left it there until the paint was dry. When I removed the rice, I got the dark shapes you see here. Compare this result with the example at right, in which salt applied to a wet painting left light areas.

■ TAKING ADVANTAGE OF ROCK SALT

Watercolor artists often use ordinary table salt to create effects such as snow or stars. In this case, I used the larger rock salt to create a field of flowers without having to paint every individual blossom. First I applied a wash of ultramarine blue and lemon yellow to my paper. Then, when the sheen was just gone, I dropped in the salt where I wanted to establish the flower design. When all was dry, I brushed off the salt and painted in the flowers' centers and stems.

■ CREATING SHAPES WITH HYDROGEN PEROXIDE

These starlike shapes were created by dropping hydrogen peroxide into a wet watercolor wash.

■ CREATING SHAPES WITH DISHWASHING LIQUID

To obtain these shapes, I squeezed dishwashing detergent onto a wet watercolor wash.

▉ *APPLYING ACRYLIC MATTE MEDIUM*

In the example at left, I dropped acrylic matte medium into a watercolor wash. Notice that there is no shine and that the shapes did not spread as much as they do with the gloss medium used in the following example.

▉ *APPLYING ACRYLIC GLOSS MEDIUM*

Try dropping some acrylic gloss medium into a wet watercolor wash to create organic and starlike shapes similar to what you see below. The gloss medium imparts a shine on the surface.

WATERCOLOR AND GOUACHE

■ TEXTURING WITH EGGSHELLS

I obtained the unusual texture at left with crushed-up eggshells that I had left in the sun to dry. First I applied acrylic matte medium to my paper where I wanted the texture, then I sprinkled on the crushed eggshells. When all was dry, I painted watercolor over this surface.

■ BUILDING GRANULAR TEXTURE WITH SAND

Sand yields beautiful texture in paintings and is one of my favorite materials. Here, I painted acrylic gloss medium on my paper where I wanted the sand to adhere, then sifted the sand onto the medium while it was still wet. (It is advisable to wash the sand you use to remove any salt or other impurities that might rot your paper.) When all was dry, I applied watercolor. Wherever the gloss medium was not covered by sand, it acted as a resist to the watercolor.

TEXTURING WITH SAND AND TISSUE PAPER

I first crumpled a sheet of tissue paper and placed it over parts of the painting where I wanted to build up textural interest (here, in the bottom third of the composition). Then I applied acrylic gloss medium to the tissue to adhere it to my painting surface, and while it was still wet, I sifted sand onto the paper. Once everything was dry, I applied watercolor, creating a landscape effect.

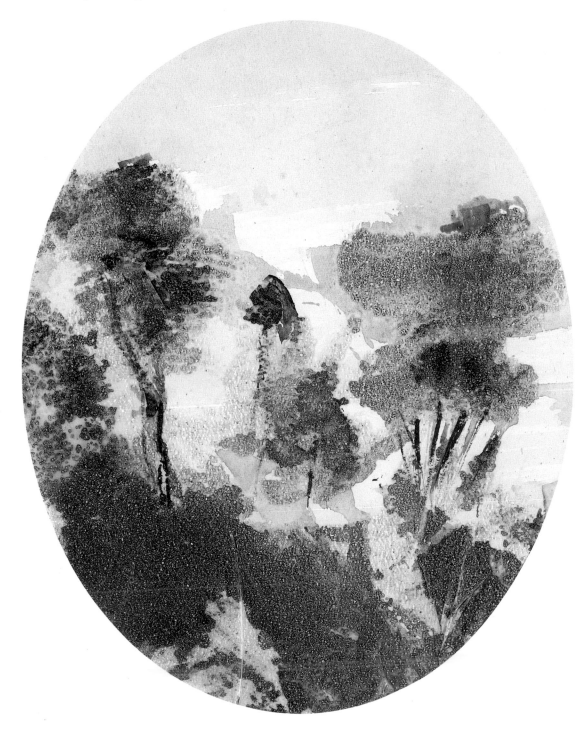

WATERCOLOR AND GOUACHE

▆▆ PATTERNING WITH WALLPAPER PASTE

To get the beautiful mottled effect shown at right, I mixed wallpaper paste (commonly available in hardware stores) with water to a viscous state and painted it on my paper. While it was still damp, I dropped in watercolor and blended it with a brush. The result would make an interesting background for a painting.

▆▆ CRINKLING PAPER FOR TEXTURE

To get the cobweb effect shown below, you need to use a lightweight watercolor paper, such as a 70-lb. (about 150 gsm) weight. Crumple up the paper as hard as you can, then open it out and wet it under the tap. Next, place it on a board and tape it down on all sides with gummed tape to stretch it. At this stage, you can either drop in watercolor while the paper is still wet or wait for it to dry, then rewet it just before applying color. The watercolor sinks into the cracks, resulting in an interesting, all-over pattern that lends itself especially well to landscapes.

▰▰▰ *WORKING WITH IMPASTO MEDIUMS*

Winsor & Newton's Aquapasto is a gel medium for
water-based paints that makes it possible to create
impasto effects. For the painting at right, I squeezed
out some Aquapasto onto my palette and mixed
some indigo watercolor with it. I then applied the
mixture to my paper with a palette knife, defining
the tree trunks by using the side of the knife. The
light areas of sky and water were achieved simply
by thinning the paint and medium mixture with
water. For the painting below, I followed the same
basic procedure, except this time I mixed my
watercolors with an acrylic gel medium; again I
applied the colors with a palette knife to build up
impasto effects. This medium dries quite glossy.

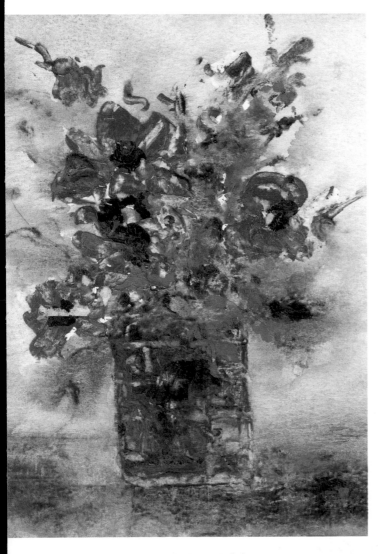

WATERCOLOR AND GOUACHE

■ EXPERIMENTING WITH MODELING PASTE

Acrylic modeling paste is a thick, translucent impasto medium that is quite flexible, meaning if used properly it won't crack when dry. In the example shown at right, I left the paste white and applied it to my paper with a palette knife and let it dry, then painted over it with watercolor. With this approach, you can easily wipe color off to establish highlights. A second approach, as illustrated by the example below, is to add watercolor to the modeling paste before you apply it to the paper. Both methods provide wonderful three-dimensional effects.

EXPLORING THE USES OF GESSO

Acrylic gesso, which is most often used as a ground for acrylic and oil paintings, can be used like the impasto mediums mentioned previously as another means for creating three-dimensional effects in your watercolor paintings. Apply gesso to your paper with a palette knife and, while it is wet, drop in watercolor. You can add texture by covering the still-wet paint with plastic wrap or impressing objects in it, as the examples on this page show. In the first, I applied sepia, raw sienna, and indigo watercolor over the wet gesso and covered it with cellophane until it was dry. This gave me a rocklike texture. In the two examples below, I applied gesso to my paper and pressed leaves and dried flowers onto one surface and seashells onto the other. When the gesso was dry, I applied watercolor over it, giving further definition to the leaf and shell imprints.

Watercolor dropped into wet gesso and covered with cellophane until dry produced this rocklike texture.

Here, leaves and dried flowers were pressed into the wet gesso and watercolor added after the gesso was dry.

In this example seashells were pressed into the wet gesso and watercolor painted over the imprint they left.

WATERCOLOR AND GOUACHE

▰▰▰ USING A HEAT LAMP

Not only is a heat lamp (one that emits infrared, not ultraviolet, radiation) useful for easing aches and pains, it also lets you create some great effects with watercolor and gouache. In fact, the procedure I followed here can be considered a variation on the sun-painting technique. For this example, I laid a wash of cadmium yellow and cobalt blue on my paper and put some leaves and a pressed fern on top while the paint was still wet. I positioned the lamp about 10 inches (24 cm) from my painting and directed its heat on the surface for about ten minutes, which "cooked" the shapes into the paper as the paint dried. Such shapes could be integrated with a still life or woodland scene for some quite interesting results.

▰▰▰ STENCILING

Artist Rona Harrison created this watercolor flower study by first applying cadmium yellow, rose madder, and ultramarine blue to her paper and letting the colors dry completely. She then made a stencil for the flower shapes from a piece of cardboard, placed it over her painted surface and, using a dampened sponge, removed color from the exposed areas.

■ COLLAGING WITH JAPANESE PAPER

The Japanese paper I used in the example at left is called Unruyshi and is one of my favorites for collaging, its lovely long fibers adding so much texture to a work. To make this little painting, I first collaged the Japanese paper randomly onto watercolor paper using watered-down acrylic gel medium as an adhesive. When it was dry, I suggested a few flowers in watercolor using the wet-in-wet technique.

■ ADDING A LACE PAPER OVERLAY

After painting some flowers, I decided to make the composition below more mysterious looking by collaging a piece of fan-patterned Japanese lace paper over it. To do this, I used acrylic matte medium. It is possible to then paint on top of the lace paper if you so desire.

■ USING FIBERGLASS IN COLLAGE

Fiberglass strands, available in hardware stores, look great when used to suggest grasses and reeds in a painting. I created the example at left by collaging the fiberglass onto my paper with acrylic matte medium, letting it dry, and then painting over it with watercolor (gouache would work well, too). It is sometimes easier to drop the strands into a dish of acrylic medium first than to coat each one individually with the glue.

■ PAINTING THROUGH TISSUE PAPER

This technique is ideal for establishing backgrounds for still lifes or landscapes, as the example below illustrates. First wet your watercolor paper, then place crinkled tissue paper on top of it. Next, apply watercolor to the tissue; the paint will bleed through it onto the watercolor paper to form delightful soft patterns, which can be worked back into later if you wish. I sometimes collage part of the tissue back onto the painting or save it for another painting. (I recommend that you use acid-free tissue, which costs only a few cents more than ordinary tissue.)

◼◼ CREATING INTEREST WITH EFFECT MEDIUM

Effect mediums are water-soluble, acrylic-based metallic inks that can be mixed with other inks, watercolor, or gouache to give a sheen to your work. In the piece at left, I laid a green and orange watercolor wash on my paper and, while it was still wet, dropped in some copper effect medium. I then placed plastic wrap over the painting. When the paper was dry, I removed the plastic wrap, revealing this interesting textural effect.

◼◼ USING METALLIC GOUACHE

Gold, silver, and bronze gouache paints are available at most art stores and can be used on their own or mixed with other colors to add shimmering effects. In the example shown below, I simply coated some leaves with gold gouache and pressed them onto my paper against a background painted in watercolor and gouache. Metallic gouache colors are handy in still life painting for rendering such objects as copper kettles and gold jewelry.

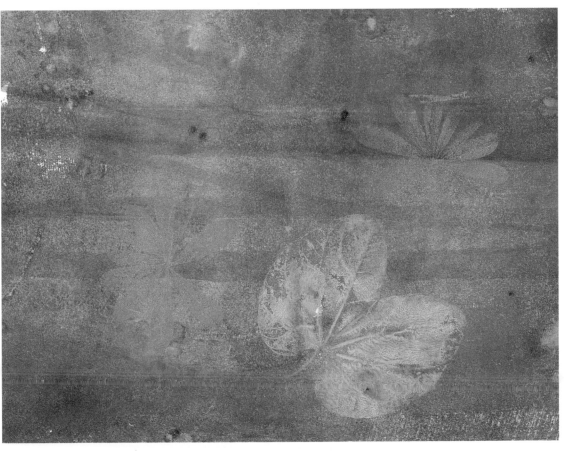

WATERCOLOR AND GOUACHE

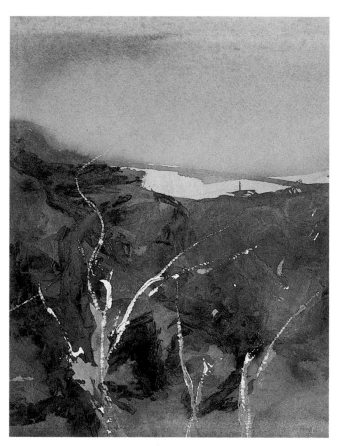

■ SCRATCHING WITH A RAZOR BLADE

This simple technique is a very effective way to add highlights to parts of your painting. Hold a single-edged razor blade with your thumb and index finger and apply enough pressure to scratch the surface of your paper, which must be bone dry and of high enough quality to withstand the abrasion. If you scratch into wet paper, you will tear it. At top left, I used the razor blade to scratch out trees in a landscape; the technique is especially useful in seascape paintings.

■ SCRAPING INTO MUSEUM BOARD

Archival-quality museum board is a rigid, multiple-ply support that is 100 percent rag and acid-free. The board's multiple layers make it possible to achieve interesting three-dimensional effects by cutting into the surface to reveal underlying layers. In the example at left below, I painted some tree trunks on my board, and then, with a scalpel blade, cut into the painted surface to create what look like peeling layers of bark.

■ TEXTURING WITH SANDPAPER

Coarse sandpaper is a good tool for creating grass textures—just be sure the paper you use it on is sturdy enough to take the abrasion, and that it is dry before you apply the sandpaper. To get the effect shown below, scrape the paper in the direction you want the grasses to go. Then apply watercolor, which will sink into the rubbed marks. When this is dry, lift out highlights by rescraping the paper. Fine-grit sandpaper is useful, too, for making small corrections or for lightening an area of a painting. Again, make sure your painting is dry before you try this.

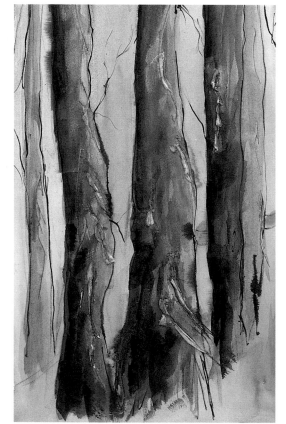

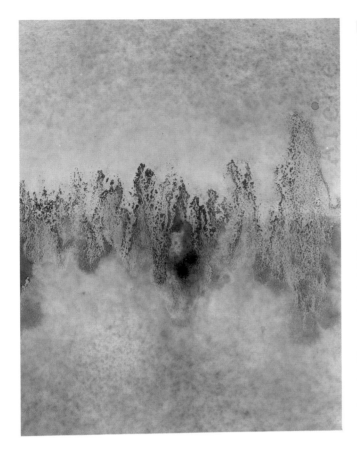

◼︎◼︎◼︎ EXPLORING GRANULATION

There are a number of sedimentary pigments that give a lovely granulation effect, especially when two or more are mixed together. In the example at top left, I used burnt umber and viridian. I flooded my paper with water, applied the paints, and moved the paper around in a rocking motion, then let it settle and dry. To get a more marked granulation effect, you can repeat the process. The grainy texture that results can be used to create mood and atmosphere in a painting and is very useful for landscapes. Some other granular colors to work with are yellow ochre, emerald green, cerulean blue, ultramarine blue, cobalt violet, light red, Venetian red, raw umber, and burnt umber. Viridian and cobalt violet is a particularly lovely combination.

◼︎◼︎◼︎ INCORPORATING CHARCOAL

As exemplified in this painting by Walter Terrell at left below, charcoal combined with a watercolor base is capable of some exceptional results. To give the charcoal a fine-textured look, the artist worked on cold-pressed watercolor paper. First he washed in a uniform, pale yellow glaze of watercolor to establish a luminous quality. The color of this first wash determines the overall temperature of the picture (warm or cool) and establishes the color of any highlights. For this technique, low-value colors, such as Payne's gray, light red, burnt umber, and sepia are to be avoided, as are opaque, tinted papers, since against such grounds the charcoal would only look dull.

Next, the artist rubbed soft vine charcoal against a piece of coarse sandpaper and applied it over the entire painting surface—which must be dry—with his finger (you can also do this with a tissue). With a kneaded eraser, he then wiped out the lights and highlights, which seem to stand out all the more surrounded by the dark charcoal. Terrell added the finishing details using the charcoal at full intensity where required, then applied a fixative to his painting, which gave it added luster.

WATERCOLOR AND GOUACHE

▬▬ USING SPONGES

All sorts of sponges can be used to create effects and textures that are especially well suited to depicting rocks, trees, bushes, and bark. In example A, I picked up gouache with a dampened kitchen sponge and applied it over a dry watercolor wash to get a very fine texture, which I used to suggest foliage. For B, I dipped a makeup sponge into two different colors and applied it to the paper with a dabbing motion. To get the effect in example C, which looks like coral, I dampened a sea sponge with water and rubbed a little household soap on it, then dipped it in masking fluid. (The soap prevents the masking fluid from clogging the sponge.)

I dabbed this onto my paper, and when it was dry, painted a watercolor wash over it (gouache would work just as well). After letting this dry, I removed the masking fluid with my finger. The open, mottled pattern in example D was also executed with a sea sponge, this time against a colored background. Trying yet another approach, I crumpled a small piece of slightly dampened kitchen sponge into a ball and dipped it into two different colors, then applied it to my paper with a twisting motion to create the two-tone circle pattern in example E. Each of these illustrations was done on dry paper; if you apply a sponge to damp paper, you get softer-edged results.

A. Fine, delicate texture achieved with a kitchen sponge.

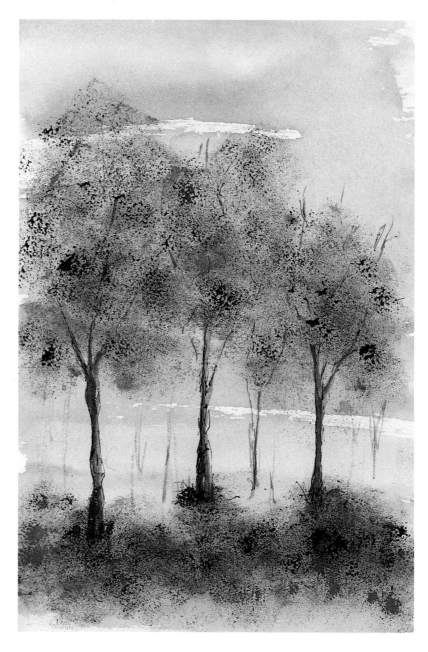

B. Two colors dabbed onto paper with a makeup sponge.

C. Coral pattern achieved by dabbing on masking fluid with a sea sponge and applying a wash over it.

D. Two colors dabbed onto colored background with a sea sponge.

E. Two-tone circular pattern achieved with a piece of kitchen sponge applied with a twisting motion.

WATERCOLOR AND GOUACHE

■ CREATING BRICK TEXTURE WITH POLYSTYRENE

Polystyrene (foam plastic) is an interesting material to apply paint with, lending its texture to the depiction of various objects, such as the brick walls in the example shown at left. To get this effect, I used a scalpel blade (heated first in a gas flame) to incise the brick pattern in a piece of polystyrene. (You can create any pattern you desire this way.) I then brushed watercolor onto the plastic and stamped it onto my paper. This technique certainly saves time when a wall is required in your painting.

■ PRINTING WITH ORGANIC OBJECTS

Transferring paint to paper using leaves and other natural objects as applicators is a wonderful way to add interesting forms and textures to a painting. To create the example below, I rubbed a little dishwashing liquid on a leaf and then applied paint to it. (Because leaves are usually a little oily, watercolor does not adhere very well without the soap.) I then placed the leaf face down on my paper, laid a second sheet on top, and pressed hard with my hand to transfer the color.

■ PAINTING WITH A TOOTHBRUSH

A toothbrush is a great tool for creating linear effects. To paint the blades of grass at right, I dipped a toothbrush in lots of paint—two colors in this case—and brushed it onto my paper in the direction of growth.

▄▄ *SPATTERING*

There are any number of ways to use spattered texture (as shown at left) in a painting. The basic method for spattering is to dip a toothbrush in paint, then drag your thumb across the brush to deposit color on your painting surface. Practice this technique to gain control over where the paint lands and how much you need for lighter or denser coverage. Try using stencils or, as I did in the center example, leaves or other objects to mask out shapes on your paper and spatter over them. This technique is very effective for making greeting cards.

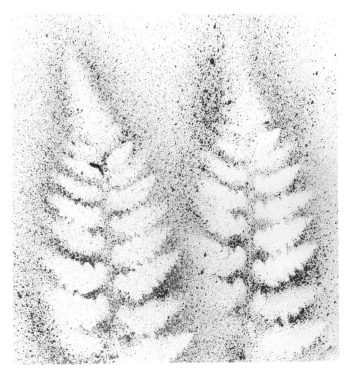

▄▄ *SPATTERING WITH MASKING AND COLLAGE*

In the example shown below, I cut masking tape into shapes and placed them horizontally on my paper, then, with a toothbrush, spattered paint over the entire surface. When this was dry, I removed the tape, revealing the white horizontal areas, and arranged the strips (which now were covered with the spatter) in a vertical pattern on the paper. I then cut out some little fish and glued them onto my painting, creating an interesting interplay of positive and negative shapes.

WATERCOLOR AND GOUACHE

■ DRAWING INTO WET PAINT WITH PENCIL

In developing the little still life at left, I decided to try a new approach. Instead of drawing the vegetables in pencil first and then applying paint, I began by dropping color on my paper quite randomly. While it was still wet, I drew the shapes around the color with a 2B pencil. When you do this, the color sinks into the pencil lines and creates a very loose effect.

■ COMBINING WATERCOLOR PENCIL WITH WASH

Watercolor pencils are excellent for outdoor painting when you do not want to carry a lot of equipment. They can be used in several ways. You can remove color from the tip of the pencil with a wet paintbrush and brush it onto your paper; draw your picture with dry watercolor pencils, then spray it with a mist of water until the colors move and merge; or draw back into a wet or dry painting with the pencils for more texture. You can also do a dry drawing first, then apply a wet brush to whichever areas call for more painterly effects. To create the painting shown below, artist Doth Smith first drew the fish with watercolor pencils, then added a watercolor wash. While this was wet, more pencil work was added.

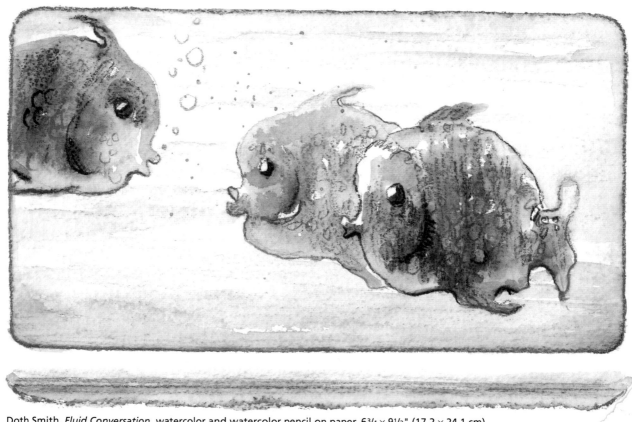

Doth Smith, *Fluid Conversation*, watercolor and watercolor pencil on paper, 6³/₄ × 9¹/₂" (17.2 × 24.1 cm).

▰▰ COMBINING CHINA MARKER WITH WASH

China markers, or chinagraph pencils, are wax-based pencils that come in several colors. Artist Jillian Brown successfully combined china marker drawings with watercolor washes to create these two illustrations. First she drew each image with china marker, then she loosely applied watercolor. Because these pencils have a wax base, they resist the watercolor, allowing the line drawings to break through. Once the paint is dry, you can work back into the composition with the china marker if you wish. This is a fast and loose way of capturing any subject matter. Note how well the blue china marker used for the still life lends itself to this subject.

WATERCOLOR AND GOUACHE

■ TEXTURING GOUACHE WITH WAXED PAPER

Waxed paper can add texture to paintings, and can also be used almost like stencils, as these two examples show. To get the effect in the top illustration, I applied several gouache colors to my paper and then placed a triangle and a square of waxed paper on top, dragging out some of the color with a brush and water. When the paint dried, I was left with the shapes of the waxed paper. Note how the wax that was left behind acted as a resist. For the second illustration I used the same basic method, cutting sail shapes and a strip to cover the water out of waxed paper and placing them on my painting. When the painting was dry, I added some detailing to the sails.

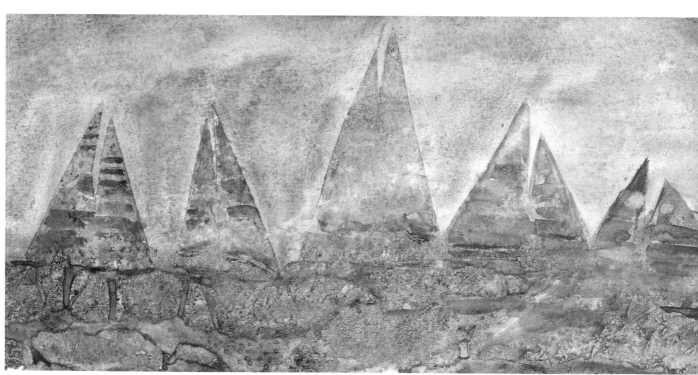

CREATING TEXTURE WITH SEAWEED

To create the effect at right, I first laid a wash of viridian watercolor on my paper, and when it was dry, applied some white gouache over it. While the gouache was still wet, I placed some wet seaweed on it, then covered the painting and put some weights on top, leaving it until it was dry. Note how the white gouache formed outlines that enhance the seaweed pattern.

STITCHING A GOUACHE PAINTING

Lesley Meaney achieved the interesting textural effects in the gouache painting shown below with a sewing machine. First she executed her painting on black paper. Next, she prepared her sewing machine with a small, thin needle and colored thread, and placed a sheet of paper under her painting. Then, following the contours of selected areas, she sewed from the edge of the painting toward the center and back to the edge, making sure not to oversew and buckle the paper. Changing to another color thread, she repeated this process in other areas. When she was done stitching, Meaney tidied up the threads at the edges of her work. With this technique, you can introduce both color and textural variety with different thread colors and different stitches.

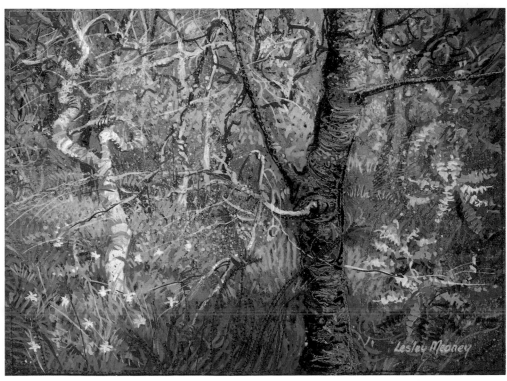

WATERCOLOR AND GOUACHE

■ MONOPRINTING WITH ACETATE

For this pair of monoprints, I laid down a wash of
two colors on my paper, pressed a piece of acetate
onto the wet paint, and lifted it to reveal a rippled
pattern. I then transferred the wet color picked up
on the acetate to another piece of paper.

Original monoprint.

Second print made by transferring paint from acetate to
paper.

■ MONOPRINTING ON PASTEL PAPER

Here, I used Ingres paper, a type usually reserved
for pastel. I simply painted two colors onto a
sheet of glass, placed the paper on top, and rubbed
the back of it with my hand. How quickly you
pull the paper off the painted surface decides the
resulting pattern.

■ MONOPRINTING ON HOT-PRESSED PAPER

I made this monoprint using the same technique
as at left but on hot-pressed watercolor paper.
Note the way the paint takes to this very smooth
surface.

■■ *MONOPRINTING WITH WATERCOLOR PENCILS*

To enhance the textural quality of the monoprint at right, I rubbed a piece of acetate with coarse sandpaper. Then I drew on the acetate with watercolor pencils, pressing hard to deposit lots of pigment. I placed my drawing face down on a sheet of dampened hot-pressed watercolor paper and rubbed over the back of the acetate with a rubber roller to transfer the color.

■■ *MONOPRINTING WITH ALOE VERA*

Aloe is a very versatile plant that is most often used in cosmetics and medicines. When a friend suggested that I try monoprinting with it, this butterfly was the result. I first cut open one of the plant's fleshy leaves and rubbed the viscous sap onto my paper. I then applied a little dishwashing detergent to a piece of acetate and left it to dry. This helps the watercolor adhere to the acetate; otherwise the paint would simply bead up. Next, I painted the butterfly's shape on the prepared acetate, then placed the acetate face down on my paper and rubbed the back of it with my hand to transfer color. The aloe makes the paper more receptive to this. After letting the print dry, I added some finishing details with a fine-point pen. The aloe gave this monoprint the finely mottled look of an aquatint etching.

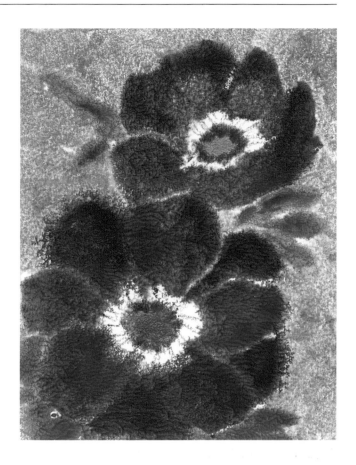

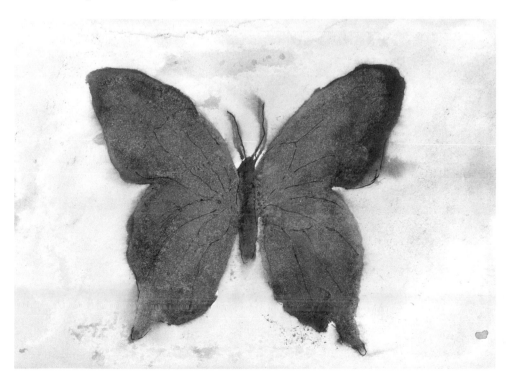

WATERCOLOR AND GOUACHE

▆▆ *AIRBRUSHING*

Both watercolor and gouache work very well with an airbrush, a tool that need not remain just in the domain of the graphic artist; used in subtle ways, airbrush techniques can enhance your paintings. For example A, I roughly tore a piece of paper to use as a template in depicting hills receding toward the horizon. I laid the template on my painting surface (a sheet of watercolor paper) where I wanted to establish the most distant hills and airbrushed across its top edge with watercolor. I then moved the template down to where the middle line of hills

was to go and again airbrushed along its edge. As I moved toward the foreground I made the hills gradually darker, using aerial perspective to create the illusion of distance. To depict the cloud shapes in example B, I simply placed cotton balls on my paper and airbrushed around them. For example C, I sprinkled clean sand on my paper and, to hold it in place, airbrushed it with a light spray of water. Next, with the airbrush, I applied ultramarine blue and then raw umber watercolor over the sand. When the sand was dry, I brushed it off and a lovely texture was left.

A. Shapes airbrushed using a paper template.

B. Clouds airbrushed using cotton balls.

C. Airbrushing through sand.

■■■ PATTERNING WITH MASKS

This watercolor by Valerie Parker illustrates a
most effective way to use airbrush in a painting.
She began by drawing in the still life, which she
then masked. Next, she applied a wash of green
watercolor to the top half of the painting, and
when the wash was dry, she placed leaves against
this background as masks and airbrushed more
green watercolor over them. The lace of the
tablecloth in the foreground was done by pinning
a strip of lace to either side of the paper to hold it
in place and airbrushing through it. When her
background and foreground were dry, the artist
unmasked her drawing of the still life elements
and painted them in.

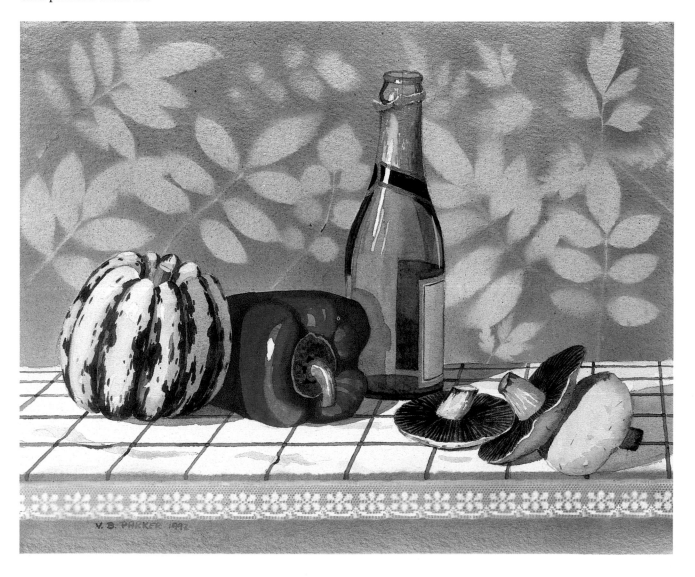

DEMONSTRATION: WATERCOLOR

■ COMBINED WITH WATER-BASED INKS

What gives this simple painting its almost organic quality is the interesting texture I created by applying waxed paper and cellophane to the wet paint. In conjunction with the watercolor paint I used for the sky, water-based inks squirted underneath the waxed paper and cellophane in certain areas enhanced the overall effect.

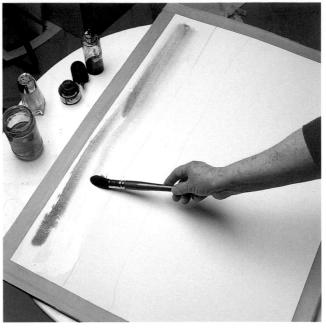

I first stretch my paper, and when it is dry, I lay in a watercolor wash of ultramarine blue for the sky area.

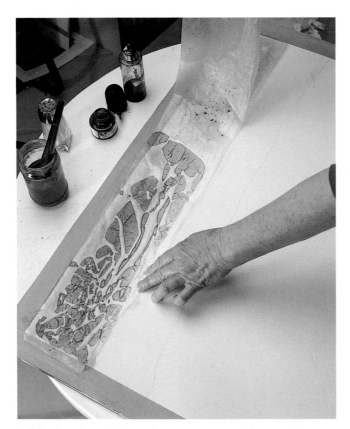

While the blue wash is still wet, I cover it with waxed paper and leave it to dry.

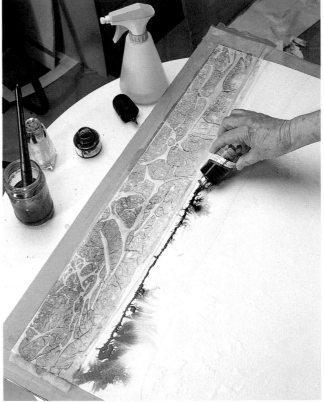

I mix together equal amounts of two water-based inks—viridian and magenta—in a bottle I got from the hairdresser. It has a fine nozzle and is great for squirting the ink. I then rewet the paper and squirt on the ink mixture along the edge of the waxed paper. This will bleed into the wet paper.

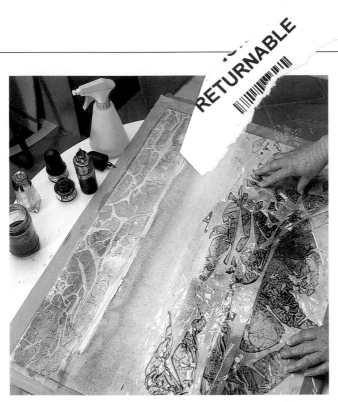

I add more of the viridian and magenta mixture to the bottom two thirds of the painting. (Together, these two colors make a beautiful gray). While this area is still wet, I cover it with cellophane and squirt a little sepia ink underneath to add some darks.

I cover the cellophane paper with a board and place a heavy weight—here, a couple of floor tiles—on top of my painting, leaving it to dry.

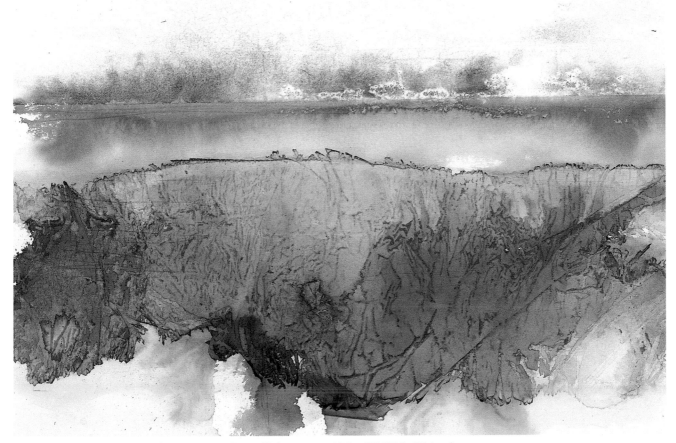

Jean Drysdale Green, *Images of Earth,* watercolor and ink on paper, 19½ × 28" (49.5 × 71.1 cm).

DEMONSTRATION: WATERCOLOR

▬▬ COMBINED WITH LACE PAPER AND GOLD LEAF

Used as collage material, delicate Japanese papers seem to have a natural affinity for watercolor paintings. Sally Douglas demonstrates this in creating *Premonition*, a work that is further enhanced by the artist's subtle use of gold leaf.

Sally Douglas stretches a sheet of 140-lb. (300 gsm) cold-pressed watercolor paper and, when it is dry, applies transparent tape around the edges to create a square format. She then lays in a graded wash of alizarin crimson and new gamboge, allows this to dry, and applies a second graded wash of new gamboge.

When the paper is dry, Douglas masks the horizon line with transparent tape and applies a mustard-colored wash to the bottom area of her painting. While this is still damp, she works in a mixture of ultramarine blue, burnt sienna, and a touch of alizarin crimson. Once the paper is dry, she removes the tape along the horizon line.

The artist rewets the orange sky and works in a strong mixture of ivory black, ultramarine blue, and burnt sienna, plus alizarin crimson and new gamboge. She allows this to dry.

With the colors used in the previous step, plus a small amount of acrylic medium to fix the color so it won't bleed upon rewetting, Douglas tints some of the Japanese paper she plans to collage to her painting. She prints some text onto a piece of Hosho paper by hand-feeding it through a photocopier. The artist then lays the prepared Japanese papers on her painting and gently glues them into place with a mixture of acrylic medium and water. When the collage is dry, she applies gold leaf sizing to selected areas, then applies a sheet of gold leaf, dusting it off lightly with a dry brush. When all is dry, she removes the tape from around the perimeter of her finished painting.

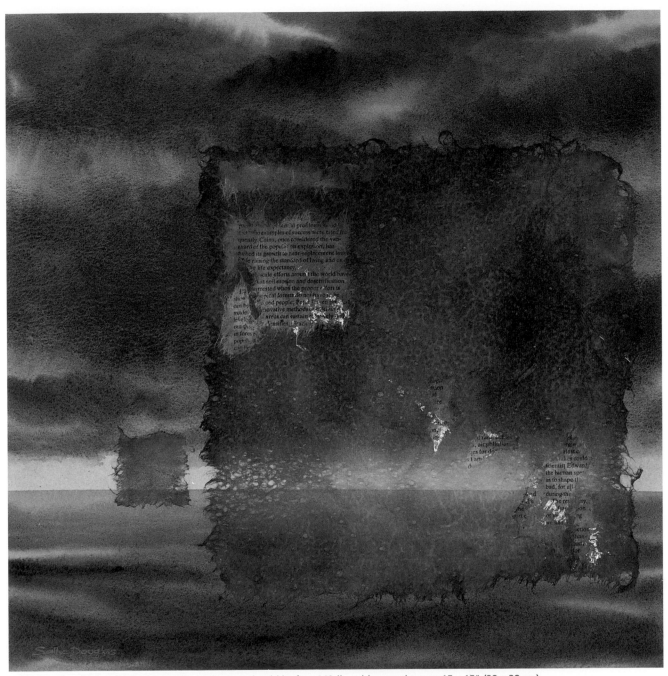

Sally Douglas, *Premonition*, watercolor, collage, and gold leaf on 140-lb. cold-pressed paper, 15 × 15" (38 × 38 cm).

DEMONSTRATION: GOUACHE

▆▆▆ COMBINED WITH PRINTMAKING INKS

To create her painting *Flowers,* artist Heather Jones successfully combines two different but compatible mediums: water-based printmaking inks (such as those used for linocuts or woodcuts; Speedball and Paillard are two well-known brands) and gouache. She rolls inks onto her painting surface to establish an abstract background, adding texture with Japanese paper. Then, on top of this ground, she paints the image she wants in gouache.

Jones squeezes printing ink onto a piece of glass (plastic or another smooth, waterproof surface will do as well) and rolls it out with a rubber brayer to get an even coat. After masking areas of her painting surface where she doesn't want this color to go, she picks up ink with the brayer and rolls it onto her painting, moving the brayer back and forth until she gets the desired color coverage.

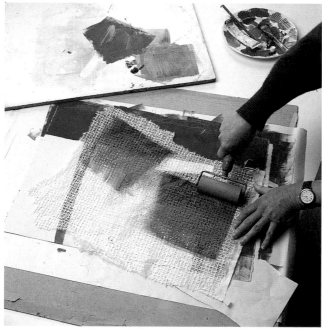

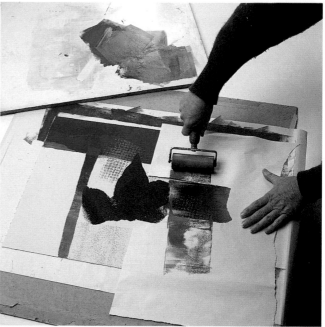

When the first inked areas are dry to the touch, Jones masks them and rolls color onto other large areas. To create textural interest, she places open-weave Japanese paper on the painting surface and rolls ink over it, transferring color through the paper's holes and thus reproducing the weave pattern in negative. (If you want the pattern to appear positive, roll ink onto the Japanese paper, then press the inked paper face down on your painting to transfer color. Be careful: fragile papers can easily tear or become wrapped around an inked brayer.) As Jones continues to develop the abstract background for her painting, she doesn't fuss or worry about details.

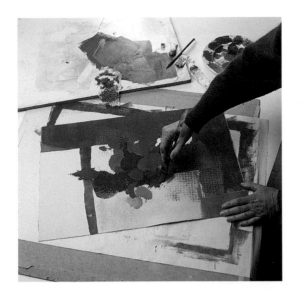

When the inked background is dry, the artist carefully works over it with gouache mixed to a solid consistency. Because gouache is an opaque medium, it can be laid over darks, but if you dilute it with too much water it won't give sufficient coverage to inked-up areas. Be aware, too, that brushing wet paint over water-based ink rewets the ink somewhat. So as not to disturb the inked areas of her painting, Jones brushes on gouache color very gently. She brings the painting along gradually, adding fine details at the very end. The artist's intention was to explore color with this subject; no attempt was made to define actual flower types.

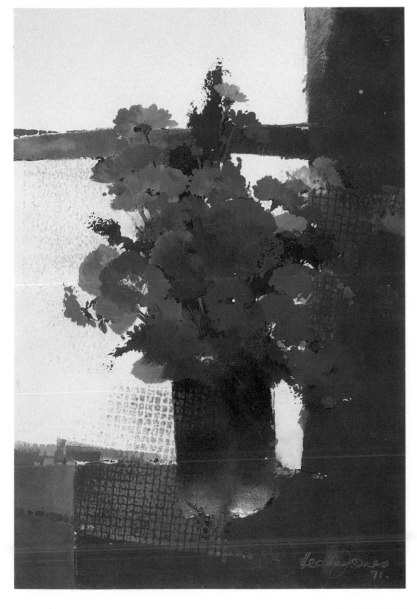

Heather Jones, *Flowers,* gouache and water-based printing ink on paper, 22 × 14½" (55.9 × 36.8 cm).

ACRYLICS

Artists' acrylic paints are a relatively new medium, having become widely available only in the early 1960s. Essentially, they are made by mixing pigment with an acrylic polymer binder suspended in water (this suspension is known as an emulsion). Other ingredients—emulsifiers, dispersants, and various agents—are added to make the paint workable.

Acrylic paint dries quickly, forming a hard, permanent, waterproof film. Because it is flexible, withstanding the contraction that occurs as it dries, acrylic can be used successfully on almost any surface that is nonglossy and free of wax or oil—canvas, heavy paper, illustration board, foam-core board, wood, even stone. You can apply acrylic directly to paper and unprimed canvas, as well as to supports primed with acrylic gesso. It should not, however, be applied over oil paint.

These paints are extremely versatile, lending themselves to opaque painting techniques as well as transparent ones. You can use acrylics as you might oil paints, even creating impasto effects, or use them thinned with water and polymer medium for watercolorlike applications. They are also excellent for airbrush work. And, because acrylic paints are soluble in water, they are a good choice for artists who are allergic or sensitive to the solvents used with oil-based paints.

Acrylic paint is available in tubes and in jars and comes in two basic forms: thick, buttery paints that feel and handle somewhat like oils, and fluid paints that perform more like tempera, gouache, or enamel.

Besides the range of "standard" hues available, today there are metallic and pearlescent colors on the market, as well as paints known as interference colors, which come in red, blue, orange, green, violet, and gold and produce some unusual effects. An interference pigment refracts, scatters, and reflects light striking it, so that its color looks different according to the angle you view it from. When applied to a white surface, an interference color at first looks nearly colorless, but when seen from another angle, appears as its complement. An interference pigment applied over a standard pigment changes the character of the underlying color, making it appear almost three-dimensional. When they are applied to a black or very dark surface, interference colors appear as iridescent pastel hues of wonderful intensity, but they then cease to show their complements.

■ PALETTE AND BRUSHES

The most practical palette to use with acrylics is a disposable one, but a glass or plastic palette is also suitable. Use high-quality bristle or hoghair brushes, since cheap ones will cause streaks. Sable brushes are desirable for fine work but are expensive; fortunately, though, many of the new, less expensive synthetic brushes work very well too. There are also affordable brushes made with blends of sable hair and nylon. If you invest in sable brushes, purchase the long-handled ones generally made for oil painters. For covering large areas quickly, 2- and 3-inch house painter's brushes are indispensable. Rounds, which are bullet shaped and have a full body that tapers to a point, are used for detail work. Brights are flat, somewhat short-haired brushes with a straight end that gives you a lot of control. Flats are similar in shape but have longer bristles. Filberts also resemble flats and brights but have a rounded end that makes them good for creating soft edges. Fan brushes are handy for delicate blending. Make sure that you wash your brushes out thoroughly in soap and water before paint or medium has a chance to dry on them.

■ MEDIUMS AND AUXILIARY PRODUCTS

Various mediums and paint-related products can be used in conjunction with acrylic paints to alter the way they perform, to prepare the surfaces you use them on, to protect finished paintings, and to broaden the range of effects you can achieve, from thin, transparent glazes to heavily textured passages. (Additional materials are listed below.)

- *Retarder* can be mixed with acrylic paints to slow their drying time, making it possible to rework or blend passages for longer periods as you would in oil painting. It is a necessity in hot, dry climates. The proportions you use depend on the manufacturer's recommendation. Normally you simply mix it with your paints, but you can also spray it onto them with an atomizer to keep them moist. Two well-known brands of retarder are Liquitex and Golden.
- *Flow medium* (such as Winsor & Newton's Acrylic Flow Improver) is a wetting agent designed to enhance the flow of acrylic colors without substantially reducing color strength. By cutting the paint's viscosity, it gives more control when thinner paint is called for, such as in airbrush

work or wet-in-wet watercolor techniques. For staining techniques on raw canvas, use flow medium and water with acrylic color to make the paint spread in a consistent manner and dry smooth, with little evidence of brushstrokes.

- *Acrylic gesso* is a flexible, rapid-drying white acrylic ground for priming canvas and other absorbent surfaces to receive polymer emulsion paints or oil paints. Colored gessoes are also available, including black, which makes an unusual start to a painting.

- *Acrylic gloss medium* is a polymer emulsion medium with many uses. Mixed with acrylic paints, it lets you create brilliant transparent glazes. It can also double as a finishing varnish— as a protective coating to help prevent surface damage to paintings. Used this way, it increases depth of color, adds gloss, and gives acrylic paintings an oil-like surface. Gloss medium is an excellent adhesive for collage, and when mixed with an equal amount of water, makes a good fixative for pastel and charcoal drawings.

- *Acrylic matte medium* is a milky, translucent polymer emulsion that when added to acrylic colors improves paint flow, increases translucency, and gives a matte finish. If used in large amounts, however, matte medium may cause clouding. Matte medium is an excellent adhesive and can be used to size canvas and other absorbent surfaces. It is not meant to be used as a finishing varnish, since it does not contain the hardener necessary for that purpose.

- *Acrylic gel medium* is a thickener that adds body and gloss to acrylic colors and makes impasto techniques as well as textural glazes possible. It is a very strong adhesive.

- *Acrylic modeling paste* is a puttylike compound of acrylic polymer medium, marble dust or calcite grit, and titanium dioxide that permits heavy impasto work, textural buildup, and sculptural effects. For use on flexible surfaces such as canvas it should be mixed with gel medium to prevent cracking. Modeling paste can be textured while still wet or carved when dry; it can also be colored by mixing acrylic paint directly into it.

- *Acrylic varnish,* available in gloss and matte finishes, is composed of acrylic resin dissolved in mineral spirits. Applied to a finished painting, it seals the surface with a hard, durable film that protects against abrasion and damage from air pollution. Gloss varnish imparts a shine to the surface of a painting, while matte varnish gives a matte, semigloss finish. (Applied too heavily, matte varnish may cause clouding.) Both kinds of acrylic varnish can be removed easily with mineral spirits when a painting requires cleaning, restoration, or revarnishing.

MATERIALS, TOOLS, AND TECHNIQUES TO TRY WITH ACRYLICS

- watercolor techniques
- glazing
- impasto
- sgraffito
- collage
- marbling
- spattering
- monoprinting
- batik
- tie-dyeing
- stenciling
- gold gouache
- interference colors
- India ink
- solvent-based inks
- mineral spirits
- Aquadhere glue
- newspaper
- pastel paper
- Japanese paper
- Chinese paper cuts
- tissue paper
- fabric
- masking tape
- aluminum foil
- plastic wrap
- spray starch
- sand
- seashells
- diatomaceous earth
- marble dust
- graphite
- slate

ACRYLICS

Acrylic paints can be used in an opaque manner or a transparent one, are soluble in water, and, in conjunction with various acrylic mediums, enable you to achieve effects that range from heavy impasto to delicate, transparent glazes. An added bonus is that acrylic mediums have tremendous adhesive strength, making them ideal for collage techniques. The illustrations in this chapter represent only a fraction of the effects acrylics permit.

■ USING ACRYLICS AS WATERCOLOR

In this monochromatic painting, I used acrylics in exactly the same manner as watercolor paints. I puddled lots of water on my paper and then dropped in color, tilting the paper to move the paint around. I then suggested the trees and, when the painting was almost dry, defined the trunks and the highlights on the water by moving the paint with a razor blade.

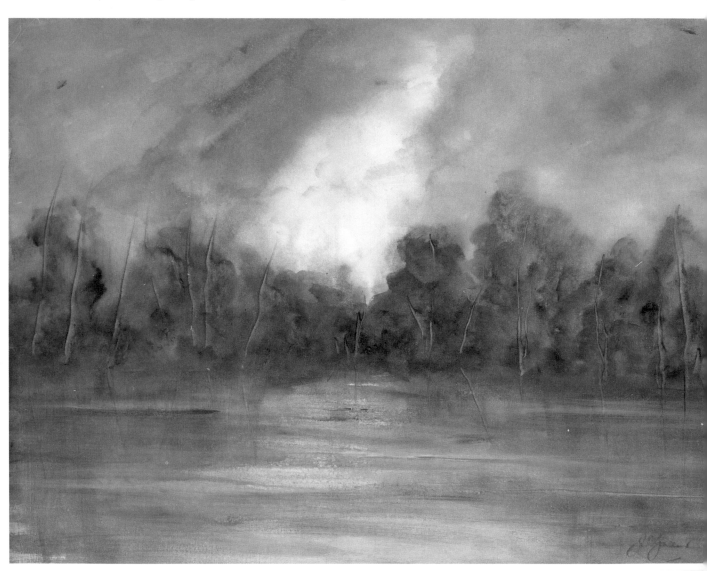

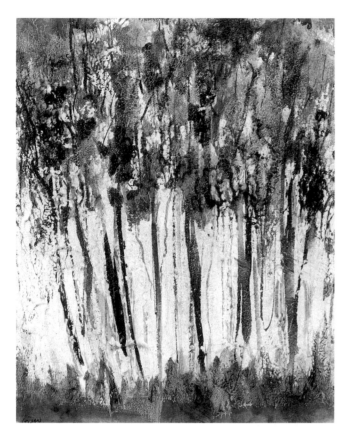

TEXTURING A GROUND WITH THICK PAINT

To get the texture shown at left, I used a roller to apply a thick layer of white acrylic paint to my paper. I let this dry, then added color on top to suggest a stand of trees.

DROPPING IN INDIA INK

Working on watercolor paper to create the example below, I applied a wash of transparent red oxide to the background and a wash of cerulean blue to the foreground to suggest water. While all this was wet, I added India ink with an eyedropper and tilted the paper to make the tree shapes. I then laid the painting flat and let it dry. As a final step, I applied a glaze of satin acrylic varnish. (You can buy a satin-finish varnish or make your own by mixing equal amounts of matte and gloss varnishes.)

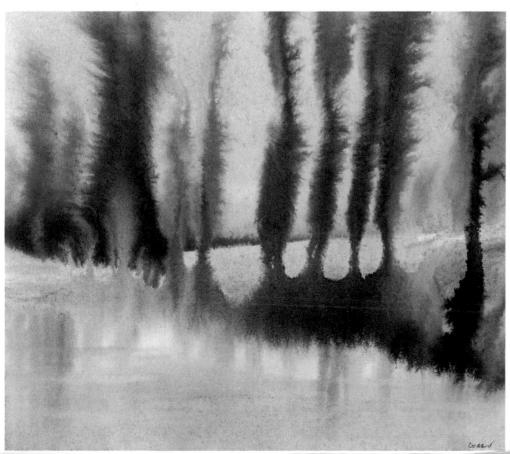

ACRYLICS

▬ APPLYING PAINT WITH NEWSPAPER

Artist Cynthia Trotter created the wonderful effects in these two examples by applying paint to her paper not with brushes but with newspaper. In the first example, she dipped a piece of crumpled newspaper in green acrylic paint and dragged it across her paper to suggest leaves. She then placed dots of light orange in the negative spaces as simple suggestions of flower centers. An image as loose as this one could easily be worked further to get a more realistic painting if desired. In the second example, Trotter lightly dipped a ball of crumpled newspaper into the same green paint and applied it to her paper with a dabbing motion. She applied the other colors in the same way, using fresh newspaper for each hue to avoid making mud. While the paint was still damp, she drew a few lines in it to suggest a creeper. This method is especially good for depicting shrubbery and trees.

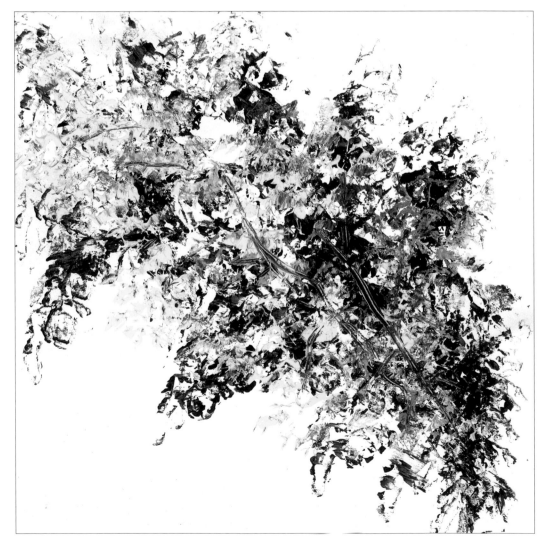

◾◾◾ *REMOVING COLOR WITH NEWSPAPER*

Just as you can apply paint to paper with newspaper, so can you just as easily create patterns and designs by lifting color off with newspaper. In the example at left, I applied paint to my paper and, while it was still wet, laid a flat sheet of newspaper over it. I smoothed the back of the newspaper with my hand, then lifted it off to reveal this interesting pattern.

◾◾◾ *REMOVING COLOR WITH MASKING TAPE*

To get the subtle pattern shown below, I applied color to my paper and, while it was still wet, dabbed the surface with a crumpled-up ball of masking tape.

TEXTURING MODELING PASTE

With a palette knife, I troweled acrylic modeling paste onto my paper and then covered it with plastic wrap. Just before the plastic wrap settled, I squirted some slightly diluted acrylic paint underneath it using a squeeze bottle with a fine nozzle (an eyedropper would also work). When all was dry, I removed the plastic wrap and discovered that a treelike image had emerged, one with a three-dimensional quality contributed by the modeling paste.

TEXTURING PAINT WITH PLASTIC WRAP

Irene Osborne created the effects shown below on a sheet of 140-lb. (300 gsm) hot-pressed watercolor paper. First, she placed strips of masking tape on her paper to isolate areas where she didn't want background color to go. Then, using acrylic paint diluted with water, she flooded the surface with color and immediately laid a sheet of plastic wrap over it, allowing the plastic to fold and wrinkle as it touched the wet surface. Leaving the plastic in place, she covered the painting with a protective sheet of paper, placed a heavy weight on top, and left it to dry. Once the paper was completely dry, Osborne removed the masking tape, revealing the white paper underneath. She then painted one of these areas to represent an old piece of wood.

▰▰▰ ROLLING COLOR THROUGH JAPANESE PAPERS

On the market these days are the most beautiful Japanese papers, and the Rakusui paper I used here is no exception. With its thin fibers and random pattern of holes, it is lovely as collage material but also yields some wonderful textures when paint is rolled through it as if it were a stencil. In example A of this technique, I laid a piece of Rakusui paper on plain white paper and rolled acrylic paint over it. The white, "negative" parts of the resulting design are where the Rakusui fibers blocked out

the paint. In example B, I established a background with acrylic paint, then picked up water-based black printing ink on the Japanese paper and transferred it onto my background to create a positive pattern of black lines. For example C, I rolled transparent red oxide and cobalt blue acrylic paint through Rakusui paper onto plain white paper. The hard-edged strip was caused by the Japanese paper wrapping itself around the roller. Textures created this way lend themselves to depicting such surfaces as old stone walls.

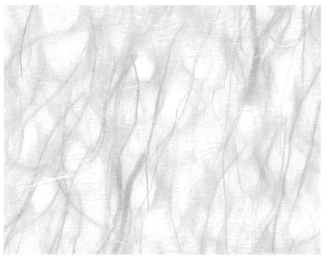

Example of Rakusui paper.

A.

B.

C.

ACRYLICS

▬▬ EXPERIMENTING WITH SOLVENT-BASED INKS

Applying the same mediums to different surfaces
often produces entirely different results, as you can
see in these examples. In the first, I put down a
wash of cadmium orange acrylic on a sheet of acrylic
paper, a matte paper with a canvaslike texture
designed for use with acrylic paints. While the wash
was still wet, I poured on some crimson solvent-
based ink and let it merge with the acrylic. Because
the ink is solvent-based and the acrylic paint
water-based, they tend to separate and form this
marbled effect. Note how the acrylic dried to a flat,
matte finish, while the ink dried shiny, creating
an interesting surface contrast. For the second
example I followed the same procedure, applying
a blue acrylic wash and then dropping in green
solvent-based ink, but this time I used very shiny
card as my painting surface. Although there are
still flat and shiny areas in the resulting pattern,
the marbling effect is much more pronounced.

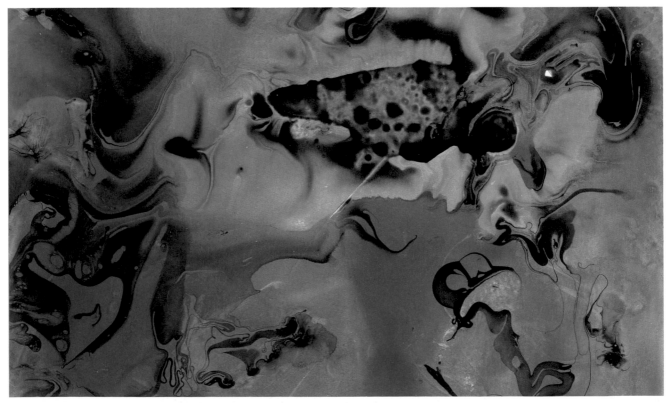

CREATING PATTERNS WITH MINERAL SPIRITS

In the first example at left, I applied a wash of dioxazine purple on my paper, and while it was wet, I dipped a wooden skewer into mineral spirits and just touched the stick to the surface of the paper. Immediately these rings appeared; such a pattern could be utilized in depicting a vase of flowers or similar subject matter. In the second example I took advantage of this effect to create an image of pebbles in a stream.

USING LIQUID STARCH

Creating the cloudlike effects in the example at the bottom of this page was very easy. I laid a wash of acrylic color on my paper and, while it was still wet, sprayed it with liquid starch. The starch pushed the color around just enough to cause a subtle pattern to form.

ACRYLICS

■■■ *GLAZING WITH ACRYLICS*

Acrylics can be used just like watercolor to create thin veils of transparent color known as glazes. Here, I used gloss medium and water to thin the paints—about 70 percent medium to 30 percent water (though proportions can vary; you have to get a feel for what's right). In the glazing technique, you work from light to dark. I began this example by covering my paper—which was dry—with a pale yellow wash. When this was dry, I glazed in some hill shapes with naphthol crimson and left this to dry. I continued to add more hill shapes, using in succession glazes of ultramarine blue and of phthalo green. By laying one transparent color over another, you create subtle new hues. Thus, to get, say, a purple, rather than mix red and blue together on your palette, you would simply glaze one over the other on your painting surface.

■■■ *GLAZING WITH SGRAFFITO AND IMPASTO*

To create this study, artist Jillian Brown began by painting a mixture of yellow oxide and flow medium on her paper. When this was dry, she mixed a glaze of red oxide and gloss medium and poured it over the first color layer, scratching back into this glaze for texture while it was still wet. Next, she mixed red oxide with gel medium to create an impasto layer, which she applied over the previous paint layers with a palette knife. She created a second impasto layer with a mixture of ultramarine blue, naphthol crimson, red oxide, and gel medium, applying this with a palette knife as well. She then applied some titanium white for a opaque effect. Finally, she mixed a thin glaze of transparent red oxide and gloss medium and poured it onto her painting randomly to get an interesting, uneven texture.

■■ *COLOR LAYERING WITH GEL MEDIUM*

Gel medium not only lets you build texture; it also lets you isolate one color layer from another, as illustrated here in a variation on glazing and masking techniques. I began these two paintings by applying gel medium to my paper with a palette knife, taking care not to apply it too thickly and leaving some of the white paper untouched. I let the gel dry, then, for the first painting (right), brushed on light yellow acrylic paint. When this was almost dry, I wiped off some of the color in selected areas with a rag. Next, I applied gel medium to the areas I wanted to keep white and yellow, and let this dry. Used this way, the medium acts like a masking fluid or resist, preserving—but unlike a mask, not hiding—whatever lies under it. I repeated this process with a succession of colors, isolating each area I wanted to preserve with a layer of gel medium. You can introduce texture at any stage; in the first example I pressed a woven nylon bag (the kind onions come in) into the wet gel, then removed it, leaving behind an impression of its texture. (A piece of gauze, screen wire, or any similar material would work equally well for this.) In the second example, below, I simply left a piece of the nylon on the painting as a collage element.

ACRYLICS

■ USING GEL MEDIUM AS A COLLAGE MATERIAL

With gel medium and acrylic paint, you can create colored shapes that can then be collaged to paintings. For the example at right, I applied gel medium quite thickly on a sheet of glass and added acrylic colors to it while it was still wet. Once it was dry, I peeled the colored shape off the glass with a razor blade and, in this case, for the sake of illustration, simply applied gel medium on the back of the shape and glued it onto a piece of paper. You can collage such shapes whole or cut them into strips or other shapes, depending on what effect you're after. Very thinly painted acrylic will tear when you try to peel it off the glass.

■ COMBINING WASHES, COLLAGE, AND INKS

To create the effect shown below, Jillian Brown laid transparent acrylic washes on her paper, allowing the different colors to mingle. When this was dry, she collaged fiberglass strands and foil chocolate wrappers to her painting. She then applied water-based inks over the collage and, when it was dry, sealed it with acrylic gloss medium.

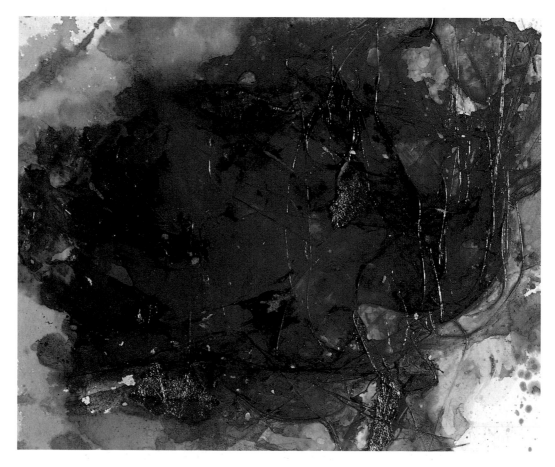

▬▬ *USING AQUADHERE GLUE FOR LINE AND SHAPE*

Carole Ayres created some interesting linear relief effects in the collage at right with Aquadhere glue. (PVA glue or any waterproof glue that dries transparent is roughly equivalent.) She began by staining a piece of canvas with green acrylic paint, which she allowed to dry. Onto this surface she then dribbled Aquadhere, forming a pattern of lines in relief. When the Aquadhere was dry, Ayres poured diluted red acrylic paint over the surface, which colored not just the canvas but the raised lines of glue as well. When the acrylic was dry, the artist collaged on various types of paper to represent tree foliage, creating some shapes by tearing and others by cutting the paper. Last, she applied gold acrylic to some of the glue lines for added interest.

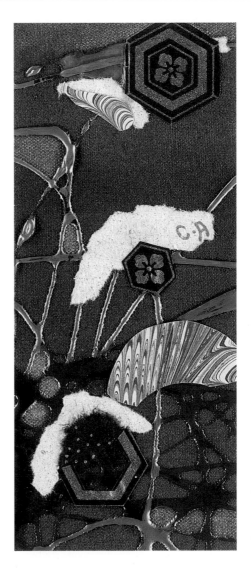

▬▬ *BUILDING TEXTURE WITH FOIL AND TISSUE*

To build up a surface that would suggest the rugged terrain of the Great Australian Bight, I crumpled up small pieces of aluminum foil and glued them to my paper with gel medium. I then tore pieces of tissue paper and glued them over parts of the foil. I added color only after these collaged elements were dry. The foil provides some wonderful texture as well as a slight sheen, while the areas I covered with tissue paper appear matte, resulting in a nice play of one quality against the other.

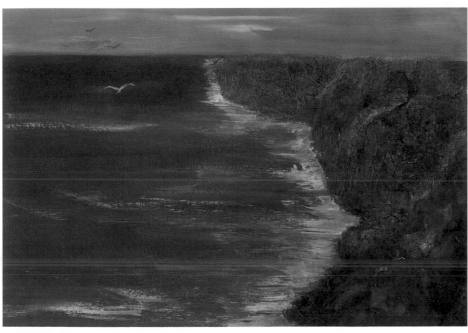

ACRYLICS

▰▰▰ TEXTURING WITH SAND

I think the texture of sand is my favorite, and I enjoy using it with everything from inks to oil paints. In the example at right, I wanted to create a tree-filled swamp scene and used Aquadhere to get this effect. To depict the trees, I squeezed glue from the bottle onto my painting surface as if I were using a drawing tool. The Aquadhere dries in relief—as a raised surface—which can be painted over later if desired. While the glue was wet, I could not resist throwing in a handful of sand to add even more texture. I painted a couple of the trees and left the others as plain glue. The five little examples shown below are samples of different kinds of sand you might want to use in a painting. Each was glued to paper with diluted gel medium. Before the glue sets, it is possible to draw into the sand to create interesting patterns.

Washed, pale beige river sand, commonly found in dry riverbeds.

Yellow ochre earth from the Australian desert.

Red earth from the Australian desert, found near Ayers Rock.

Sand colored blue with an airbrush.

Combination of various sand colors.

ADDING DIMENSION WITH SHELLS AND SAND

To achieve a realistic, three-dimensional effect in this painting, artist Alex Wisniewski glued shells, grit, and sand to his primed canvas with PVA glue (white glue). He has suggested spatial depth by graduating the size of these elements, placing the largest shells in the foreground and, as he worked toward the background, applying progressively smaller, finer texturing materials. Eventually, with a mixture of sand and acrylic gesso, he tapered the texture out until it melded with the s... canvas. Wisniewski then painted over the text... surface completely with gesso, tinting it with acrylic paint to establish an appropriate ground color. The gradual transition from the reality of the shells to the illusion of the painted surface was accomplished with multiple layers of acrylic color applied in a pointillist method, the artist making his brushmarks largest in the foreground and progressively smaller toward the background.

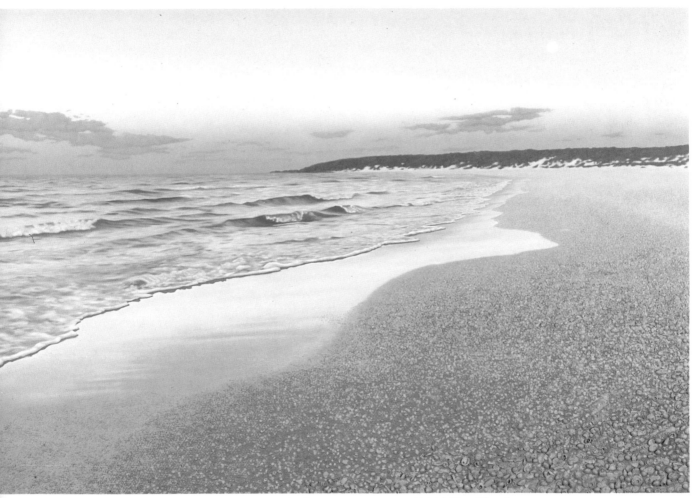

Alex Wisniewski, *Twilight, Geographe Bay,* acrylic and collage on canvas, 47 1/4 × 70 7/8" (120 × 180 cm).

ACRYLICS

◼◼◼ APPLYING MODELING PASTE THINLY

One of the most versatile acrylic mediums is modeling paste, which enables you to get wonderful textures and three-dimensional effects. For the example at right, Jillian Brown applied a very thin layer of modeling paste to her paper with a spatula. To get the texture you see here, she lifted the spatula very quickly and put it down again, so that the modeling paste formed ridges and valleys. Once the paste was dry, Brown poured on four diluted acrylic colors, allowing them to merge. When the paint was dry, she glazed over the surface with a mixture of red violet acrylic and matte varnish.

◼◼◼ ACHIEVING ORGANIC EFFECTS

Taking a very elementary approach, I simply put modeling paste on a piece of paper with a palette knife, placed another piece of paper on top, pressed the two sheets together with my hand, and then pulled them apart. This left me with the two interestingly textured surfaces shown below, one a mirror image of the other, and both good starts for a painting. This technique tends to produce very organic-looking patterns that are particularly useful for depicting plants. These two examples resemble coral.

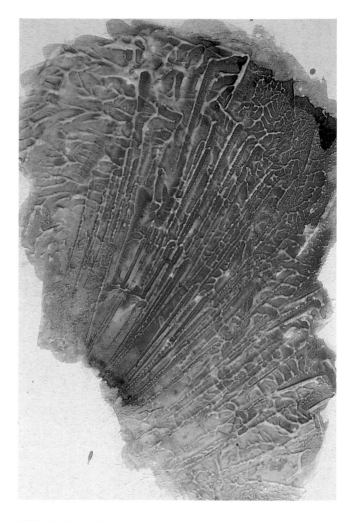

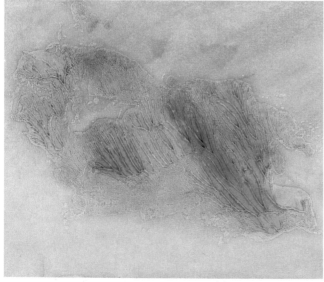

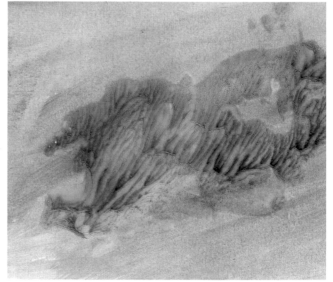

ENHANCING RELIEF EFFECTS WITH SAND

Sand added to acrylic modeling paste makes for some really luscious textured relief effects. In the example at left, Jillian Brown applied modeling paste to paper (canvas would also work) and sprinkled some washed riverbed sand onto it. She allowed this to dry. Next, she mixed a glaze of red oxide acrylic and flow medium and poured this onto her painting surface. This was followed by glazes of French ultramarine and red violet; the colors were allowed to mix by themselves. When all was dry, the artist applied gloss medium to increase the sense of transparency.

The example shown below, Patricia Goff's painting *The Restless Earth I,* was created with a combination of acrylic paint, gel medium, sand, and diatomaceous earth.

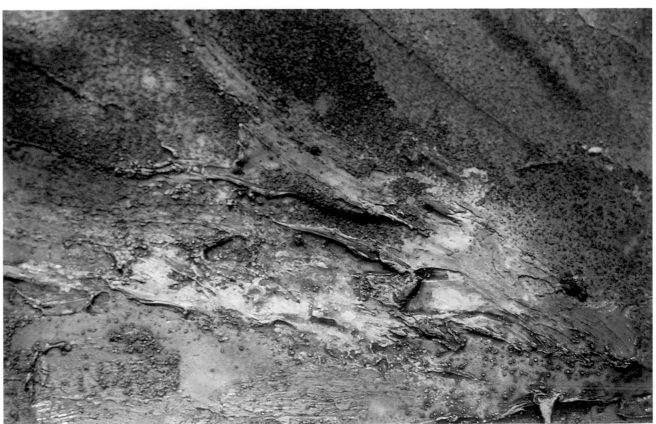

Patricia Goff, *The Restless Earth I,* acrylic, sand, and diatomaceous earth on canvas, 4¹/₂ × 7" (11.4 × 17.8 cm).

ACRYLICS

▌▌▌ *BUILDING INTERESTING IMPASTO EFFECTS*

In each of the examples on this page, artist Patricia Goff enhanced her impasto effects with diatomaceous earth, a light, crumbly, sandlike material composed of the remains of tiny plankton known as diatoms. (It is used as a filter and can be found in shops where swimming pool supplies are sold.) In the first example, *Evening Capriccio IV,* she used acrylic gel medium to build up the painting's surface. To create the examples below, she applied modeling paste to paper with a large spatula and worked in the diatomaceous earth. When this was dry, she washed acrylic color over the top, achieving a lovely soft, dry look by not using any glazes. These examples, with their torn, uneven edges, would be great as collage material.

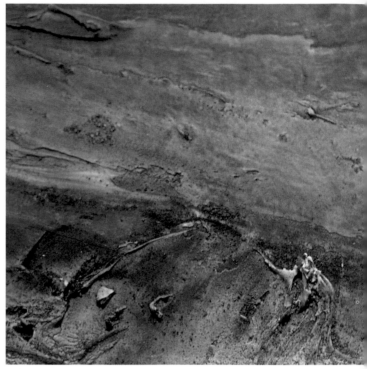

Patricia Goff, *Evening Capriccio IV,* acrylic and diatomaceous earth on canvas, 3¹/₄ × 3¹/₄" (8.3 × 8.3 cm).

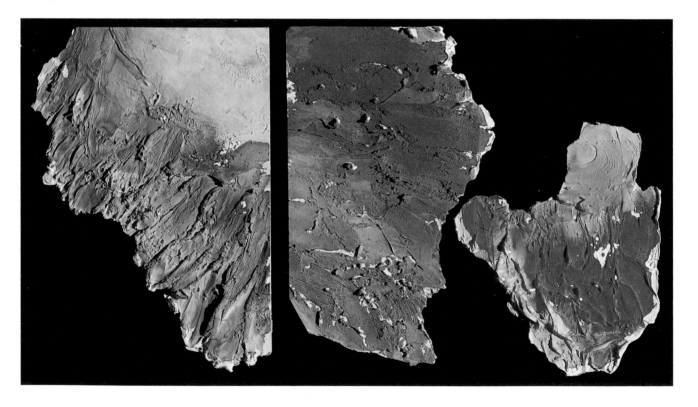

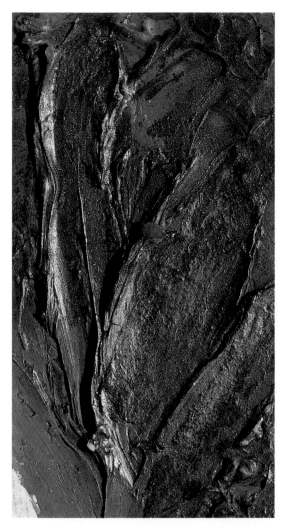

■■■ WORKING WITH POWDERED GRAPHITE

Graphite's beautiful silvery-gray sheen and interesting texture can add a lot to a painting. At left, Patricia Goff used it in conjunction with thick, boldly handled modeling paste for some exciting results. Used as heavily as in the manner shown, modeling paste requires a firm support such as thick, strong card or board. Goff applied the paste with a big building trowel, vigorously working in diatomaceous earth to produce a lovely, rough but also absorbent surface. She shook off surplus diatomaceous earth and left her work to dry, but just before the modeling paste dried completely, she worked some powdered graphite into the surface. Using a soft brush, Goff then painted over this thickly textured ground with acrylic paints, finally sealing it with a thin layer of matte medium.

■■■ USING MARBLE DUST WITH MODELING PASTE

I wanted to create a rough texture to indicate the rock face of a quarry. To get this effect, I mixed marble dust with acrylic modeling paste and applied it to paper with a painting knife, then, with a nail file, incised lines to represent crevices in the rock face. Color was then applied. When this was dry, I rubbed powdered graphite into the cracks between the rocks, then varnished the painting.

ACRYLICS

CREATING RHYTHM WITH SGRAFFITO

Here, Patricia Goff established a rhythmic pattern
of lines by scratching into the modeling paste on
her painting surface. After applying acrylic color,
she added even more texture by pressing a crumpled
bag into the wet paint. More washes of color were
applied, and then the surface was sealed with a
semimatte glaze.

■■ *TEXTURING WITH MESH AND GOLD GOUACHE*

In the example at right, Patricia Goff knifed modeling paste onto her painting surface and, while it was still a little damp, pressed fine wire mesh into it to create interesting texture. This was left to dry. Goff then applied acrylic paint, gold gouache, and watered-down sumi ink to her work, leaving some areas unpainted for compositional interest.

■■ *PAINTING ON SLATE*

Acrylics work on many unexpected surfaces, even slate, as the painting by Carole Samuels shown below illustrates. In choosing a piece of slate for a painting, Samuels assesses its shape and color quality in relation to her subject. For this particular painting, she wanted her ground to look like a fragment from an ancient Egyptian wall, hence the rough edges. She washed the slate with water to remove any dust, dried it off, and, without an undercoat of primer, began to block in the composition using watered-down black acrylic paint. She then proceeded with her painting. Painting on slate normally takes two coats, as the first coat sinks into the surface. When the work was dry, Samuels applied a final protective coat of acrylic varnish. The artist likes to frame works like this one behind glass to make them look like museum specimens.

Carole Samuels, *Weighing the Heart,* acrylic on slate, 15 × 30" (38.1 × 76.2 cm).

ACRYLICS

■ TAKING ADVANTAGE OF A MODERN MEDIUM

For generations, Australian aborigines have handed down their legends and stories not with written language but in drawings and paintings characterized by symbolic imagery. In this highly developed art form, aborigines paint objects from above, as though from a bird's-eye view, using simplified designs complex with meaning to indicate, for example, marks left by people or animals. Traditionally, aborigines use paints made from different-colored ochres gathered in the Australian desert. Alma Toomath, a well-known contemporary aboriginal artist and teacher, also works in the traditional earth colors of burnt sienna, yellow ochre, black, and white, but in the very nontraditional medium of acrylic paints. In the painting shown here, a hunting scene done as a class demonstration, she rendered the hands and feet by applying paint to plywood templates of these shapes and stamping them on her canvas. She used a satay stick to paint the dots, which can represent rain, ants, or eggs. A plastic cylinder was used to depict the circles symbolizing water holes, while the edge of a piece of cardboard was used to depict the straight white lines symbolizing spears.

■ *MASKING WITH TAPE*

To get hard-edged shapes, Jules Sher put masking tape to good use. He chose a sheet of Arches 300-lb. (640 gsm) rough watercolor paper, tearing it to the required size against a steel ruler to simulate the deckled edge of the original sheet. To this he applied three coats of gesso to seal the paper's porous surface and prevent it from ripping when removing the masking tape used later in the painting process. When the paper was dry, he penciled a border around the area to be painted.

Step 1. Sher taped the prepared paper to his drawing board with masking tape, covering the marked-off border. He laid in an overall wash of yellow oxide, let it dry thoroughly, then covered it completely with masking tape. Next, he drew his design onto the masking tape with a soft pencil; then, using a scalpel, he cut into the tape covering the river shape and removed it, leaving the paper exposed there. He painted this area with umber and orange and, after allowing it to dry, applied metallic silver paint over it with a palette knife, letting the orange and umber show through here and there. He then removed the rest of the tape and allowed the work to dry.

Step 2. Sher remasked the whole painting surface and drew in the moon and rock shapes on the tape, cut the tape away from them, and painted these areas with a brush and a palette knife. When dry, he removed the surrounding tape.

Step 3. The artist masked the painting once again, this time cutting away tape to reveal the background. He painted this area quite freely with a palette knife, and removed the remaining tape while the paint was still wet. With all of the compositional elements in place, he refined various areas, aiming to preserve the painting's original definition and freshness. After waiting a week for the paint to cure completely, he applied a coat of acrylic varnish to the painting and removed the tape holding it to the drawing board.

Step 1.

Step 2.

Step 3 (finish). Jules Sher, *Moon, Rock and Silver River,* acrylic on paper, 11 × 9¹/₂" (27.9 × 22.9 cm).

115

ACRYLICS

■■■ INTERPRETING ABORIGINAL THEMES

Shane Pickett, a Nyungar aborigine, has devoted much of his painting career to interpreting his native culture's visual traditions in innovative ways. To create the marbled background for this painting, Pickett carefully poured five different acrylic colors diluted with water into a bucket, making sure they did not mix. Next, he poured this liquid paint onto his canvas and let the colors merge. When this was dry, he masked the middle third of the painting and applied a delicate spatter over the rest, incorporating aboriginal imagery in the form of dots and circles. Against this background he painted the two spoonbills.

Shane Pickett, *Spoonbills,* acrylic on canvas, 32 × 28" (81.3 × 71.1 cm).

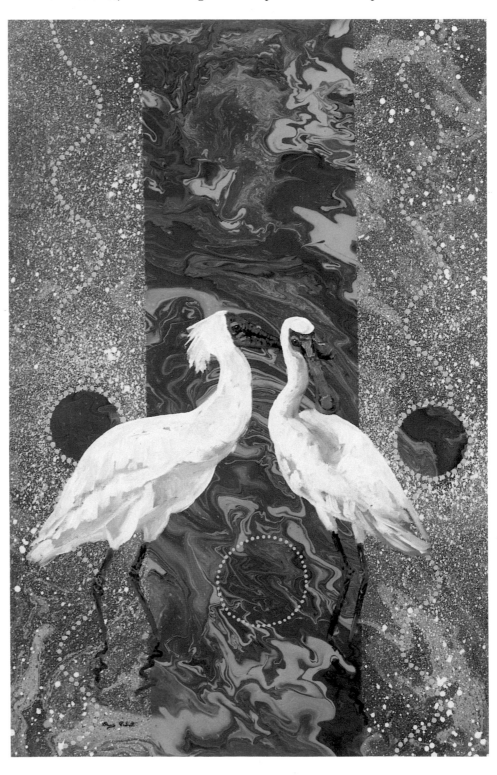

COLORING A MONOPRINT WITH ACRYLICS

In the monoprint at right, Lynne Tinley successfully combined acrylics with oil-based printing ink by exploiting the way water-based and oil-based mediums repel each other. First, she rolled out black printing ink on a sheet of glass. Over this she laid a sheet of mulberry paper, and drew her design on the back of it with a pencil. When her drawing was completed, she peeled the paper off the glass and turned it face up. Because the ink is tacky, it transfers to the paper only where pressure is applied. After leaving her monoprint to dry for about twenty-four hours, Tinley hand-colored various areas with acrylic paint. Whether you apply the paint in thin, transparent washes or in an opaque manner, the large areas of printing ink will repel the water-based paint.

MONOPRINTING LINE DRAWINGS

To create the textured line drawings shown below, I rolled acrylic paint and a little gel medium onto a sheet of glass. I placed a piece of paper on top of this and drew my design on the back of the paper with a ball-point pen (any sharp instrument would work). I then removed the paper from the glass; the image on the front appears in reverse from the original drawing. In my first example, I used brown paint and white paper, so the drawing appears in white line. In the second example, I used yellow paint and black paper, so the drawing appears in black line. By adding more paint and more line drawing, quite a unique surface can be obtained.

Lynne Tinley, *Egrets,* oil-based ink and acrylic monoprint on mulberry paper, 9 × 5 1/8" (22.9 × 13 cm).

ACRYLICS

◼◼◼ *MONOPRINTING ON COLORED PAPER*

Instead of using white paper, try monoprinting
on colored paper. For these two examples, I used
a blue and a black sheet of pastel paper. First
I rolled out acrylic paint (including some gold) on
a sheet of glass, then I placed paper on top of the
paint and rubbed the back of it with my hand to
transfer the color (you can also use a roller for this).
The images and effects you get when you pull
the paper off the glass often suggest interesting
directions for paintings.

▆▆▆ *MONOPRINTING WITH CHINESE PAPER-CUTS*

I have had several beautiful Chinese paper-cuts like the one shown at left below for years and decided to use them in a monoprint method. The basic method was this: I rolled out some acrylic paint on a sheet of glass and placed the paper-cut (which is colored on both sides) on top of the paint, then covered this with a piece of paper and rolled over it with a brayer to transfer color. In example A, I used only one color; in B, the paint was a little thinner and drier, so I got a more typical monoprint texture. For example C, I rolled up two colors before placing the paper-cut on the acrylic. In D, I added a little gel medium to the paint to get a different texture. In all of the prints, notice that some of the color from the paper-cuts transferred onto the paper along with the acrylic, enhancing the effect.

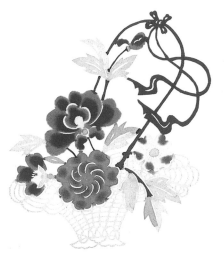

Original Chinese paper-cut.

A.

B.

C.

D.

ACRYLICS

▰▰ EXPLORING INTERFERENCE COLORS

Interference colors are unusual and fascinating paints to try. Unlike conventional pigments (such as alizarin crimson) and metallic pigments (such as gold or silver), interference pigments contain the mineral mica, which causes light striking it to refract, reflect, and scatter. When applied to a white surface, interference colors appear almost colorless, but when seen at another angle, "refract" their complementary color. For example, interference red appears green in a certain light, and violet appears yellow. The effect is similar to what you see in a thin coat of oil floating on water. However, it is nearly impossible to show in a photograph. Applied on a dark ground, such as black paper, interference colors appear as iridescent hues of startling intensity, but no longer refract their complements. Mixed with other acrylic colors, they give a pearlized effect.

▰▰ CREATING COLOR TRANSFORMATIONS

This comparison shows what happens when you put a wash of interference color over "conventional" colors. The same hues were used to paint both examples. In example A, no interference color was used, but in B, a glaze of red interference color was applied over the painting, changing the blue of the sky and the green bushes to a red-mauve and the yellow hill to an orange. An overall shimmering effect is visible, too. (Due to photographic limitations, these effects may not be readily apparent.)

Interference colors applied on white paper. Left to right: green, red, blue, gold, violet.

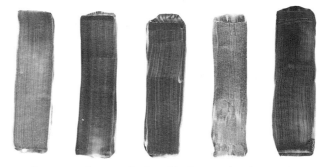

Interference colors applied on black paper. Left to right: green, red, blue, gold, violet.

A. Acrylic painting without interference color.

B. Acrylic painting executed in same colors as A, but with red interference color applied on top.

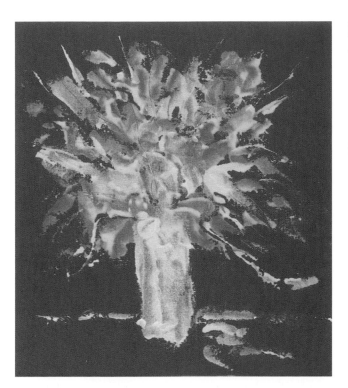

■ USING INTERFERENCE COLORS ON FABRIC

At left, I brushed interference colors onto a brown cloth napkin. Against this dark background, the pearlescent effect is quite visible, but the complementary color effect does not occur.

■ MARBLING WITH INTERFERENCE COLORS

To create the lovely example of marbling shown below, Pegi de Angelis placed interference colors of gold, red, and blue on a surface of carrageenan treated with a photo wetting agent to ensure that these relatively heavy pigments would stay afloat. She moved the colors with a skewer, then laid a sheet of black pastel paper on top, gently rocking it to get the lines shown. Marbling of this type would look great in a book cover design or on fabric, particularly on black silk.

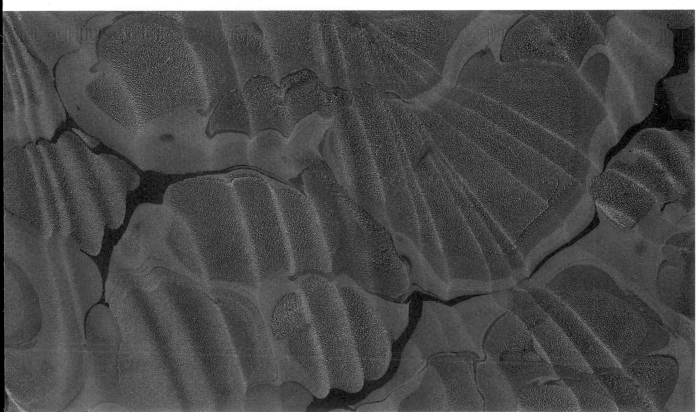

121

ACRYLICS

■■■ *WORKING WITH A RANDOM WAX PATTERN*

I executed this very free painting using a technique
adapted from batik. I filled a tjanting—a pointed
metal tool used in traditional batik—with melted
beeswax and let it create lines on the paper wherever
it wanted to. I then dropped acrylic paint into the
spaces between the lines of beeswax. While this was
wet, I sprinkled on some gold powdered pigment.

▰▰▰ CREATING BATIK DESIGNS ON CLOTH

Artist's-quality acrylic paints can be used very successfully on most fabrics, as long as you wash the cloth first to remove any sizing. Paint can be applied in a watercolor technique or by airbrushing. For permanency, the color should penetrate the fiber, not sit on top of the fabric. Lynne Tinley created the interesting example at left on a piece of heavy cotton. She lightly outlined her design in pencil, then traced over this using paraffin wax in a tjanting tool. (Alternatively, the wax can be applied with a brush.) She then brushed on acrylic color thinned with water—yellow in some areas, blue in others. When the paint was dry, she applied wax over the areas that were to stay yellow and blue. Next, Tinley brushed on a darker blue; then she laid a red wash over some of the yellow areas to create oranges, and a blue wash over other yellow areas to create greens. Once this was dry, she applied a few more textural lines of wax and some final touches of darker colors. When the paint was quite dry, she placed the cloth between several sheets of newspaper and ironed it, replacing the newspaper as needed until all the wax was removed. Designs done in this manner glow wonderfully when placed over a light source such as a window or lamp. Thus they are excellent for curtains, blinds, lampshades, or as appliqués on these.

▰▰▰ USING GEL MEDIUM FOR BATIK

Instead of wax, I used acrylic gel medium as a resist in creating this batik design. With a brush, I applied the medium to a piece of washed white silk where I wanted to reserve white areas. When this was dry, I brushed on various acrylic colors (thinned with water), which will not penetrate the gel medium. When the paint was dry, I soaked the silk in warm water, which softened the gel enough so I could peel it off to reveal the white lines. To avoid the kind of distortion you see in this example, stretch the silk taut before applying the gel medium.

ACRYLICS

■■■ MARBLING ON FABRIC

Acrylics make marbling on fabric very easy. To create the two examples at right, I poured some liquid laundry starch into an aluminum foil tray. After mixing my chosen colors with water to a fairly thin consistency, I dropped them onto the starch with an eyedropper, then moved the colors around with a skewer until a pleasing pattern emerged. I placed fabric on top of the inks for a few seconds to pick up color, then laid it flat to dry.

■■■ TIE-DYEING WITH ACRYLICS

For the tie-dyed example shown below, I tied a piece of washed cotton with string and dropped it into a puddle of acrylic paint diluted with water. I then removed the cloth from the paint, leaving the string in place until the cloth was dry. When dry, I cut the string and unfolded the cloth, revealing the design. Tying the cloth different ways gives you a variety of patterns. When you use acrylics for this technique, do not wash the fabric for a few days afterward to ensure that the paint is fully cured. When tie-dyeing a T-shirt, you may want to spray the color on rather than dip the shirt into a paint bath.

▰▰▰ PAINTING DIRECTLY ON FABRIC

Although the design at left looks as if it had been done using a batik process, in fact Lynne Tinley created it simply by painting on a piece of black fabric with thinned acrylic paints. The black lines you see are the color of the fabric; the artist simply painted around them, negative-fashion.

▰▰▰ STENCILING ON CLOTH WITH ACRYLICS

Illustrated below is another way to use acrylic paints on cloth. I cut a stencil and positioned it on a piece of fabric where I wanted to start my repeating design. Using a stencil brush (you could use a piece of sponge), I simply applied the paint with a dabbing motion. (If color spreads under the stencil, your paint is too thin.) I then picked up the stencil, positioned it at an interval from the first part of the design, and repeated the process. This technique could be used to create a design on a lampshade, curtains, or around the hem of a skirt.

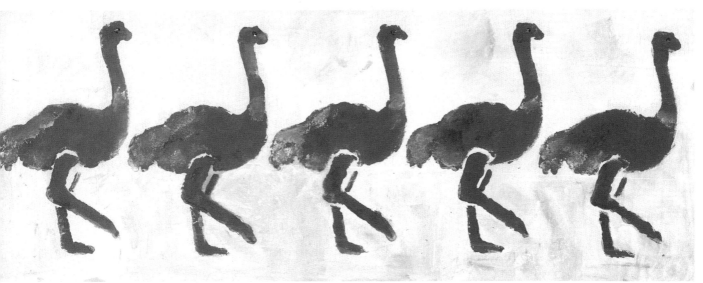

ACRYLICS

CRUMPLING CANVAS FOR PATTERN

Irene Osborne created these beautiful effects using unstretched canvas primed on one side, a linoleum roller, and acrylic paints. She crumpled the canvas, holding it primed side up with one hand. With the other hand, she rolled up some paint and applied it to the crumpled canvas. She released the cloth and repeated the process in another area. To maintain crisp edges of paint, she allows one application to dry before overlapping it with another. If you want to leave small areas without texture, cover them with masking tape before starting. The canvas may be glued to a board or stretched onto a frame after you are satisfied with the amount of texture achieved. By spraying the back of the canvas with a little water before stretching, most of the crinkles will be removed as it dries. Small amounts of crinkling not removed by this process add to the overall effect.

Irene Osborne, *Pilbara—Summer Season,* acrylic on canvas, 25 × 23" (63.5 × 58.4 cm).

OILS AND ENCAUSTIC

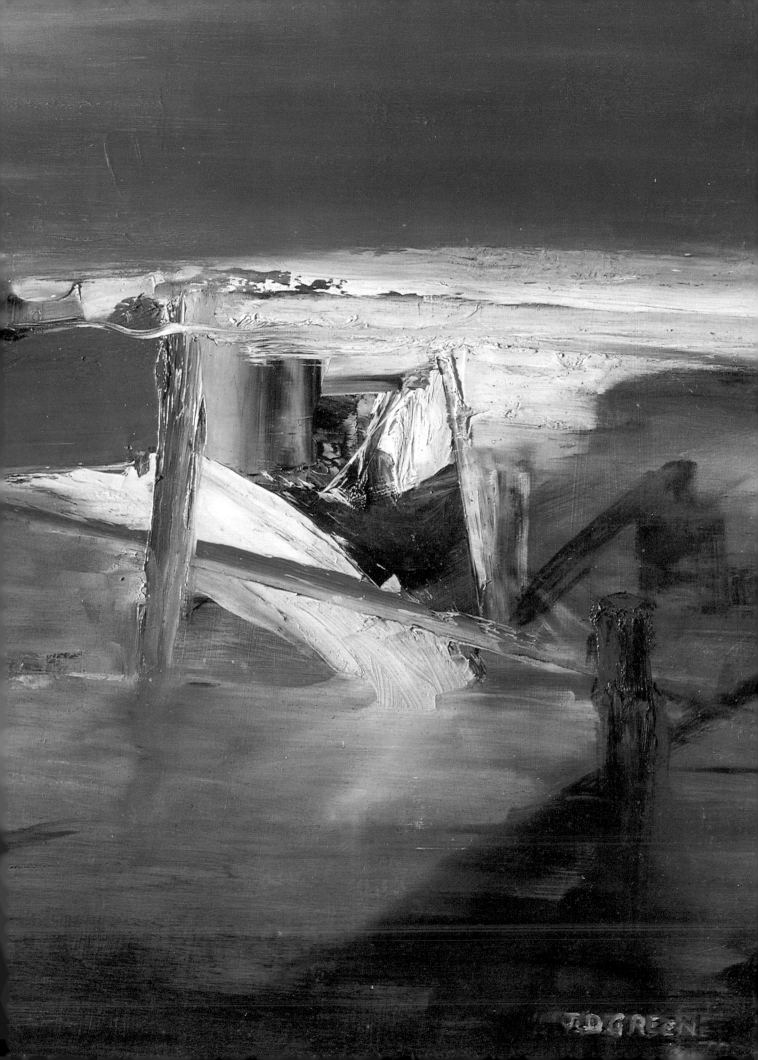

O

il painting as we know it today has a long tradition that extends back to the fifteenth and sixteenth centuries. One of the most appealing qualities of this medium is its brilliance and glow. With oils, you can achieve both transparent and opaque effects, a glossy finish or a matte finish; you can work thick or thin, create luminous glazes as well as heavy impasto, apply paint with a brush or spread it on with a palette knife.

This chapter includes the increasingly popular oil sticks, which are basically oil paints made into a paste and molded into large crayons. Included, too, are some modern adaptations of the ancient medium of encaustic, in which color is mixed with hot wax and painted onto a surface, then fused with heat.

▬ OIL PAINTS

Oil paints are composed of pigments ground in a drying oil—usually linseed oil—and often contain a thinner and drier as well. Alkyd paints are made with a binder of alkyd resin rather than linseed oil and are faster-drying than oil paints.

The solvents most often used with oil paints are gum turpentine and mineral spirits. A well-known painting medium is Winsor & Newton's Liquin, an oil-modified alkyd resin used to thin and speed the drying time of oil and alkyd paints. Another general-purpose medium for oils and alkyds is Winsor & Newton's Win-Gel, a clear, fast-drying alkyd resin gel designed to increase the gloss and transparency of colors. For thick impasto effects, oil paints can be mixed with an extender such as Winsor & Newton's Oleopasto.

When working in oils, the rule of thumb is to paint "fat over lean"—meaning that each successive layer of paint must contain more oil than the layer beneath it so that as the paint dries, the upper layers are flexible enough to allow for shrinkage without cracking. In other words, thin turpentine washes belong in the bottom layer of a painting, while the oiliest layer belongs on top.

Oil paints are usually applied to canvas (Belgian linen is the finest) stretched over a wooden frame called a stretcher, or to smooth wood or Masonite panels. Both types of surfaces must be primed first, usually with acrylic gesso or acrylic medium. Another possibility is canvas board, made of primed canvas glued to stiff cardboard; you can also glue gauze to hardboard and coat it with gesso.

High-quality rag paper is a fine support, too, as long as you prime it with two coats of acrylic gesso.

As for brushes, the workhorses of oil painting are those made with stiff white hog bristles; they come in a range of sizes and shapes, including flats, rounds, filberts, and brights. For smooth, precise work, brushes made with a combination of natural and synthetic soft hairs are handy. For detail work, a sable or oxhair brush is best.

Palette knives are for mixing paint on the palette, scraping off mistakes, and cleaning your palette at the end of a painting session. A painting knife is different: It has a thin, flexible blade and is used for applying paint to the canvas to create impasto effects, and for spreading color. The side of the blade is useful for rendering fine lines.

The palettes best suited for oil painting are made from plywood or hardboard coated with varnish to prevent oil from sinking into the wood. If you don't like to clean your palette, then disposable, oilproof paper palettes are for you. When you've finished a painting session, you simply tear off the used sheet and throw it away.

Palette cups are designed to hold turpentine and painting medium and clip onto your palette. They should be emptied and cleaned after each painting session.

▬ OIL STICKS

These are oil paints in stick form and are made by combining pigment with linseed oil and a blend of waxes. Popular brands are Shiva Artists Paintstik and Oilbar. Oil sticks differ from oil pastels—if only slightly—in that they contain more oil and wax, which gives them a buttery consistency and slippery feel. Another distinction is that they contain driers, meaning that the paint film they produce will dry within a few days, whereas oil pastel may take many years to dry to a hard finish.

Oil sticks have the directness of pastel or charcoal, yet also behave like rich, creamy paint, even permitting impasto effects. You can use them as drawing tools, sharpened to a point for fine line work, or apply color in big, painterly swaths. You must, however, observe the same principle of "fat over lean" that applies to working with oil paints.

With oil sticks, color blending generally takes place on the painting surface, not on the palette. Colorless wax blending sticks can be used to spread

and blend colors or make them more transparent. Mediums such as Winsor & Newton's Liquin, Win-Gel, and Oleopasto may be used with oil sticks much as you would use them with oil paints.

Oil sticks work well on most surfaces, including paper, canvas, mat board, wood and Masonite panels, and plastic. Most supports, but especially absorbent ones like paper and canvas, need a coat of acrylic gesso or acrylic medium for protection. Oil sticks can be used over completely dry oil and acrylic paints.

Because they don't require brushes or a lot of other equipment, oil sticks are especially useful on field trips. They are a versatile, convenient alternative to oil paints in tubes—and you don't have to remember to put the caps back on, as they seal themselves!

ENCAUSTIC

This art comes down to us from ancient Egypt (where it was used in mummy portraits) and Greece. The process involves mixing pigments with a binder of melted refined beeswax and damar varnish. Once this mixture has been applied to a painting surface, it receives a final heat treatment, or "burning in" (the meaning of the ancient Greek word for this technique), and is then polished with a soft rag to give a satin sheen.

For encaustic painting, you need a heating tray, some muffin or cake tins to put your colors in, and a propane torch or heat lamp. Ready-made encaustic colors are available, or you can make your own using melted wax crayons. The grounds most commonly used for encaustic painting are Masonite coated with a thin layer of gesso, and canvas mounted on a stretcher and primed with gesso or a wash of acrylic color.

In the basic process, you apply a coat of melted pure beeswax to your painting surface; upon subsequent reheating, this layer helps to amalgamate the colors you apply on top of it. Colors are painted on with a brush or palette knife. The hot wax color solidifies very quickly and travels only a few inches at a time, so handling it may take some getting used to. Fortunately, mistakes can easily be melted and removed. Once the painting is complete, heat is applied to fuse the colors. When you apply heat, work from the top of the painting down, moving on when the surface looks just wet; do not let it get too hot or a runny mess will result.

MATERIALS, TOOLS, AND TECHNIQUES TO TRY WITH OILS AND ENCAUSTIC

WITH OIL PAINTS:
- knife painting
- miniature painting
- wiping out
- watercolor techniques
- marbling
- monoprinting
- glazing
- carving
- collage
- tissues
- plaster relief
- bookbinder's gauze
- masking fluid
- masking tape
- gold leaf
- Hydroseal
- soil
- marble dust
- sand
- alkyds

WITH OIL STICKS:
- drawing
- sgraffito
- monoprinting
- watercolor techniques
- collage
- Liquin
- colorless blender
- oil pastel
- Oleopasto
- sand
- palette knife

WITH ENCAUSTIC:
- gold pigment
- acrylics
- wax crayons
- gauze
- sand

OIL PAINTS

Unlike water-based mediums, oil paints stay moist for days, meaning you have a longer time to work out a composition. You can build paintings slowly in layers, or work in a rapid, direct manner, applying paint in loose, expressive strokes. Whether you use them in traditional ways or in experimental ones, oil paints are immensely satisfying to work with; they take well to many different kinds of handling and combine readily with a variety of materials.

■ PAINTING THICK AND THIN

In the example at top right, thick paint was applied with a palette knife, while thin paint was rubbed into the canvas with a hoghair brush. Used together, these techniques complement each other; here, the contrast between the dark, thickly handled color and the thin, translucent blue-green suggests rocks and water.

■ PAINTING WITH A PALETTE KNIFE

A gutsy impasto effect is achieved by using a palette knife to apply paint to canvas. In this first example (right) I worked wet-in-wet, picking up three colors on the knife at the same time and boldly stroking them onto the canvas. I used a very free approach to paint *Marigolds,* opposite. The whole painting was done very quickly wet-in-wet, and only at the finish did I use a brush to smooth out some of the background and vase. After approximately six months, when the painting was fully dry, I applied a varnish to it to protect the surface.

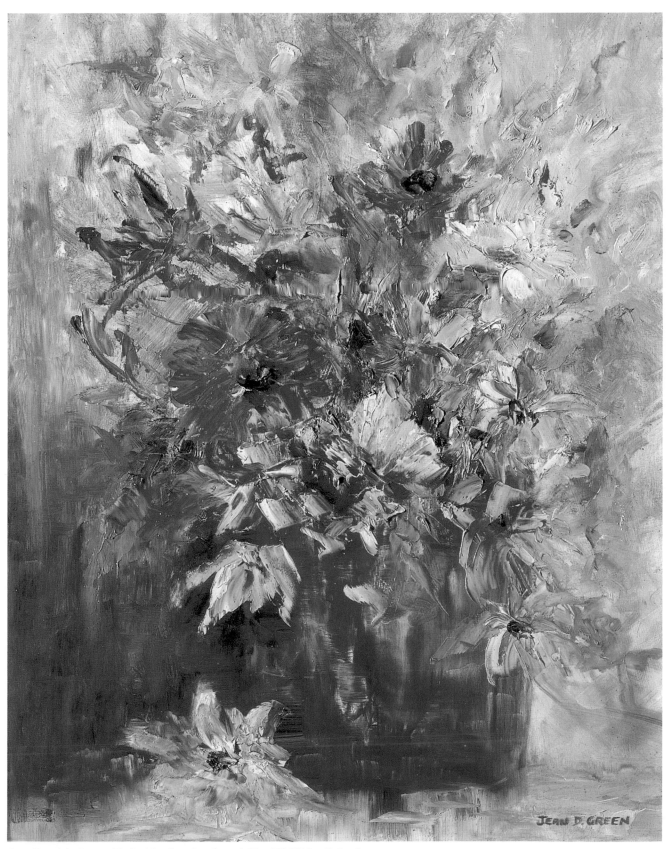

Jean Drysdale Green, *Marigolds,* oil on hardboard, 20 × 16" (50.8 × 40.6 cm).

OIL PAINTS

▬ GLAZING

During a stay in Italy, Judith Dinham came to appreciate the rich, resonant color qualities she saw in paintings by the Old Masters, who achieved these effects with the glazing technique. This method involves the buildup of many thin, transparent layers of oil paint to create the impression of great depth. In her own work, Dinham discovered that glazing enabled her to describe the mellow light and colors of the Tuscan landscape.

The traditional glazing method is a lengthy process because of the time required for each layer of paint to dry before another one can be glazed over it. Nowadays, modern materials like Liquin make drying time a lot shorter. In the work shown here, the artist first established an underpainting in colors that were complements of those she intended for her finished painting. For example, green areas of the composition were underpainted in reddish colors. Over the dry underlayer, Dinham applied her intended colors generously with a brush and a painting knife, allowing areas of the complementary underpainting to show through to

keep the color effects alive. At the completion of this stage, the colors were "right" but bright and unintegrated. The glazing stage followed.

To create her glazes, Dinham mixed Liquin with minimal amounts of oil color, using more or less paint depending on how dense she wanted the color but always keeping the glaze very transparent. For this painting, a green glaze was mostly used, but in some areas a glaze of a complementary color was applied to tone down a particular hue and unify the colors of the overall painting. Dinham applied the glazes across the canvas and then wiped back in places with a lint-free cotton cloth, her fingers, and the side of her hand, sometimes waiting till the glaze was partially dry and tacky to dab into it. This is a good way to achieve soft, indistinguishable edges. In other cases, she completely wiped off the glaze immediately after applying it, leaving just a residue of transparent color in the brushmarks of the dry underlying paint. The artist continued to layer on and wipe back glazes until she achieved the desired effect—color with tremendous depth and resonance.

Judith Dinham, *Garden Mosaic,* oil on canvas, 22 × 34" (55.9 × 86.4 cm).

■ WORKING IN MINIATURE

After working in miniature for the past several years, Cecilia Netolicky found that she could pack as much information into formats of two or three square inches as she had previously presented in paintings measuring three or four square feet. The example shown here, measuring just 2 × 2³/₄" (5 × 7 cm), was executed on a textured oil paper. With no preliminary drawing, Netolicky blocked in the basic compositional elements with a turpentine wash using a size 0 sable brush. Most of the rest of the painting was carried out with a 4/0 brush, along with 6/0 and 7/0 brushes for fine detail.

When the turpentine wash was dry, Netolicky applied a second layer of paint, this time using it full strength to develop the three-dimensional quality of the compositional elements—the leaves are rendered as fat, succulent shapes, the sun modeled as a solid-looking sphere. In the final stages, touches of pink and turquoise were introduced here and there to move the viewer's eye through the work. Fine black or colored lines were laid next to objects to make their hues appear more intense, the aim being to achieve a jewellike quality. Even the signature and date, rendered in a color echoed elsewhere in the painting, have been used as vital design elements.

Cecilia Netolicky, *Emu Nightscape,* oil on paper, 2 × 2³/₄" (5 × 7 cm).

Detail, *Emu Nightscape.*

135

OIL PAINTS

◼◼ WIPING OUT

This technique is a subtractive one, meaning that you develop an image negatively—that is, by removing color from an overall field. It can also be used very effectively for creating highlights. Here, at top right, Allan Baker painted his surface with burnt umber and, while it was wet, used a rag dampened with turpentine to wipe out the light areas and highlights of his subject. He achieved the texture of the woman's sweater by sponging that area with a piece of crumpled newspaper dipped in turpentine. (This texturing method is useful for depicting such subjects as trees and rocks.)

◼◼ USING OILS AS WATERCOLORS

Spurred by a desire to paint in watercolors but put off by the paper preparation involved, Leonid Zuks developed a style of working in oils that solved his artistic dilemma. This process is spontaneous in the coloring stage, but a lot of meticulous work precedes this. To create the painting shown at right below, Zuks chose his subject matter by referring to sketches, drawings, and photographs. Next, he made a master drawing on a thin piece of paper and, using a light box, transferred this image to the heavier paper that became his painting support. (Typically, he may transfer an image to two or three sheets of paper.) Placing the drawing on a sheet of glass, Zuks soaked the paper with turpentine, draining off any excess. Using oil paints diluted with turpentine to the consistency of thin washes, he worked color into the drawing, adding dark lines with pencils and highlights with oil paint. He also wiped off color with turpentine-soaked rags to create highlights, making sure not to overwork the drawing or let it become muddy. The artist then put the painting on a drying rack and assessed it later. Once dry, works created this way can be touched up with most any medium; Zuks often uses oil pastels for this.

Allan Baker, *The Sitter,* oil on hardboard, 24 × 18" (61 × 45.7 cm).

Leonid Zuks, *Nude,* oil on paper, 36 × 24" (91.4 × 61 cm).

■■■ TEXTURING WITH A TOOTHPICK

Roma Biagioni begins her paintings with no firm idea of how the finished work will look. She always starts by creating a textured surface, letting it guide the direction the painting will take. She pins raw, unstretched canvas to a wall, securing the corners firmly. The wall provides the needed support for the pressure she exerts as she boldly knifes on thick gesso with a painter's spatula; the paint stretches and shrinks the canvas to the right tension as she works. Biagioni achieves a variety of effects with very simple tools. For this painting she used a toothpick to incise the fine lines that inspired her composition. Once this texture was established, she applied a thin wash of yellow ochre over it, creating an underpainting whose warm glow would show through subsequent paint layers. She darkened some areas with a thin mixture of brown pink and

Pilbara red. Next, using a thin mixture of raw umber and cadmium red, she depicted an Australian landscape scene, including a big rock, a running bird, wildflowers, and two small aboriginal figures. She darkened shadows and other areas of the rock, bird, sky, and land with spectrum violet, Tasman blue, and lilac. In the foreground, Biagioni added more yellow ochre and Australian grey to help create the illusion of distance. She further defined some areas and played down others, emphasizing the focal points of bird, figures, and sky with more layers of paint. She indicated the foreground flowers and grasses with quick calligraphic strokes, adding final details to the flowers with a small brush and a mixture of raw umber and cadmium red deep. (Pilbara red, Tasman blue, and Australian grey are colors indigenous to Australia and are made by Art Spectrum.)

Roma Biagioni, *Kakadu National Park,* oil on canvas, 16 × 12" (40.6 × 30.5 cm).

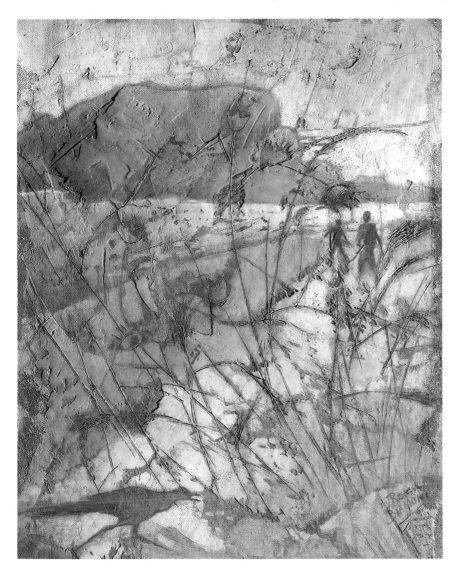

OIL PAINTS

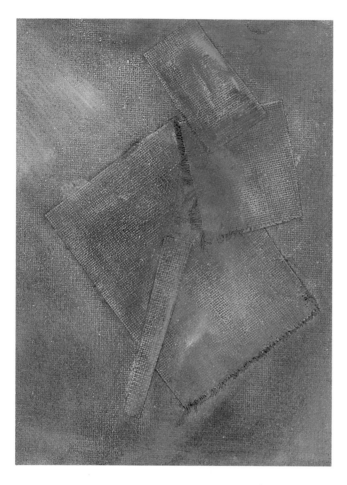

COLLAGING WITH FABRIC

All sorts of things can be collaged onto canvas; in the example at left, I glued canvas to canvas, using acrylic gel medium as an adhesive. For added interest, I left some of the edges of the collaged elements frayed. This always looks great in an oil painting and is a good way to use up scrap canvas.

In the example shown below, a detail from a painting titled *Limpets On,* artist Gladys M. Dove used lace, open-weave cotton, and netting as collage elements. She established her design in acrylic on stretched primed canvas and glued these materials onto the surface using acrylic medium, to which she added color to enhance the feeling of depth. Making the collage elements an integral part of the painting support from the beginning this way minimizes problems that can arise from applying them toward the end of the work, when integration may be more difficult. Next, Dove applied a thin glaze of oil color and, while it was still wet, applied thick paint as well using a palette knife. When this was dry, she again applied thick paint, this time using beeswax as an extender. While this was still wet, she poured a glaze of thin paint over it, which resulted in a gentle bleeding of edges. She let this dry just until a skin formed, then poured a light glazing medium over it, encapsulating the fat paint. This created surface tensions during the drying period that ultimately resulted in a crazing of the outer surface, exposing earlier layers of color.

Gladys M. Dove, detail, *Limpets On,* oil and collage on canvas, 78 × 48" (198.1 × 121.9 cm).

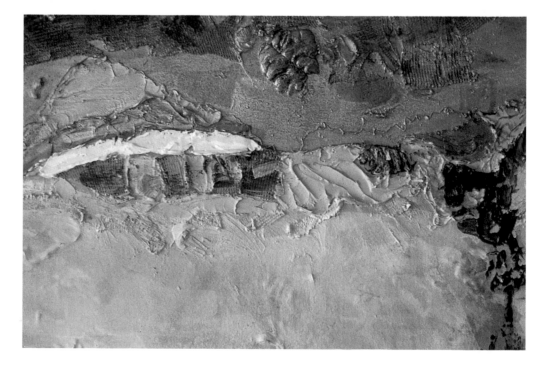

▰▰ WORKING ON PRINTED GAUZE

Glen Hughes discovered an interesting painting support quite by accident. While she was operating an offset lithography press, a few sheets of paper came through creased, the ink on them forming geometric and organic patterns that to her appeared as very convincing semiabstract landscapes. Hughes was inspired to further explore the potential of this chance discovery but was restricted by the size of the press and by the fact that it could accommodate only lightweight papers, which are not ideal for oil painting. She then stumbled upon a fabric called mull, or bookbinder's gauze, which is lightweight and flexible enough to go through the press rollers. The gauze adheres beautifully to board with PVA glue, resulting in a surface not unlike canvas. It also adheres well to good-quality paper. Hughes then works into surfaces prepared this way with oil paints (she has found equal success with acrylics), often mixing natural ochre pigments with them as she did for this painting. It is interesting that marks made by a machine can evoke the beauty of nature, calling forth memories and releasing the imagination.

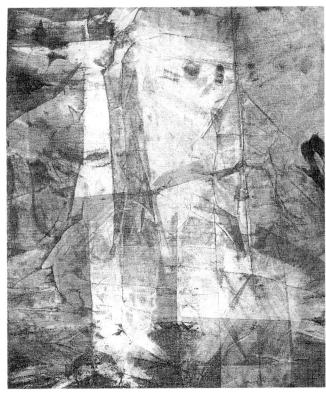

Bookbinder's gauze printed on an offset lithography press.

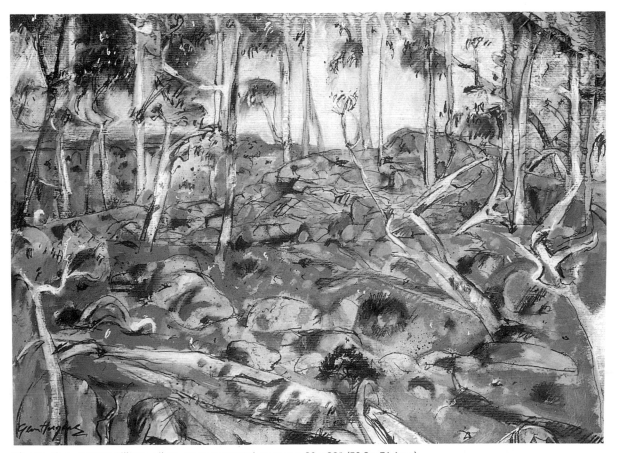

Glen Hughes, *Eastern Pilbara,* oil on gauze mounted on paper, 20 × 28" (50.8 × 71.1 cm).

OIL PAINTS

▮▮▮▮ TEXTURING PAINT WITH MARBLE DUST

One of my favorite ways to paint is to juxtapose thick, impasto passages with smooth ones. In the swatch shown at right, I mixed marble dust with my paint to achieve an impasto look that is subtler than that achieved by mixing sand with the paint. I usually add a little medium to the oil paint when using marble dust so that the mixture does not become too stiff.

To create my painting *Abandoned Open Cut Coal Mine* (below), I actually sat in the mine as I aimed to convey the feeling of water, machinery, and coal in an abstract way. I feel that the low-key colors I used help relay this message to the viewer. I used a combination of thick and thin paint. For the heavily textured areas, I mixed the paint with marble dust and applied it with a palette knife; for the water and smoother parts of the composition, I brushed the paint into the surface quite vigorously using lots of medium (turpentine and oil).

Oil paint mixed with marble dust.

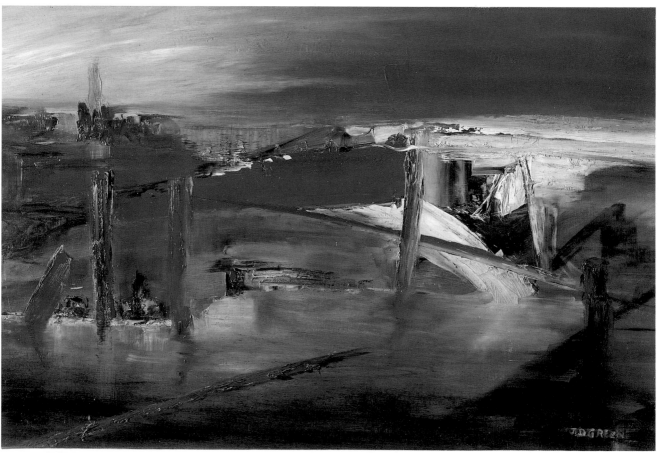

Jean Drysdale Green, *Abandoned Open Cut Coal Mine,* oil on canvas, 24 × 36" (60.1 × 91.4 cm).

▬▬ *TEXTURING PAINT WITH SAND*

Sand is my favorite texturing medium. In this particular example, I mixed sand with oil paint and a little linseed oil and applied it directly to a piece of canvas. Another way to incorporate sand texture in a painting is to first glue it to your canvas using acrylic gel medium, then paint over it with oils.

▬▬ *TEXTURING WITH POWDERED PIGMENT*

Powdered pigments are yet another means for adding texture to oil paint. They are available in art supply stores, and some are readily available in nature, such as the ochres found in the Australian Outback. In this case I mixed gold powdered pigment with my paint, leaving some of it to show through unblended.

OIL PAINTS

■ *TEXTURING WITH SOIL*

When Brendon Darby is on painting trips in the Outback, he often collects soil samples of different colors and consistencies for use in paintings of the area. Despite the large range of colors available commercially, this artist makes his own from these naturally occurring ochres and other earth pigments, as he finds it gratifying knowing that his paintings physically contain some of his subject. However, the main reason he uses soil is to add texture to his work, as can be seen in his painting *As Night Climbs the Escarpment,* shown on the following pages. Described here is his basic procedure.

Once Darby has selected the soil he wants to use, he grinds it to the right consistency (usually very fine) with a mortar and pestle, then mixes it with gesso for use on unprimed canvas. As the artist explains, you have to be careful not to use too much soil, as it may cause the gesso to lose its adhesive properties and result in an unstable painting. Other problems will occur if the gesso and soil are not very thoroughly mixed. If you wish to change the ground color, you can add a little acrylic paint at this stage. If you intend to glaze over this prime coat (as Darby does), keep it light and consider how it will look when combined with subsequent glazes. If you require more body in the underpainting, you can add some impasto medium.

Darby applies this mixture to unprimed canvas using a brush or a large flat trowel, keeping in mind that all the lumps and bumps will be seen in the final painting and considering how their placement will affect his composition. When this is thoroughly dry, he gives the whole canvas a coat of transparent acrylic sealer for added protection.

To this interesting surface, Darby usually applies a combination of transparent oil glazes and some opaque glazes, which he rubs back or wipes off. For transparent glazes, he mixes a little oil paint with a lot of medium. In example A (above), over a textured gesso primer tinted with yellow, he applies an initial glaze of alizarin crimson, followed by, as shown in B, a glaze of phthalo blue. This way he effectively uses the three primaries. Opaque color can be added at any stage and rubbed back so that it gets caught around the textured areas of the painting but still shows some of the transparent glazes, as in examples C and D, opposite. Darby likes to finish his paintings by loading a brush with oil paint and working into the final glaze while it is still wet.

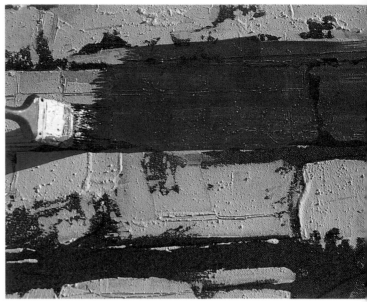

A. Applying a transparent red oil glaze over a gesso ground textured with soil and tinted yellow.

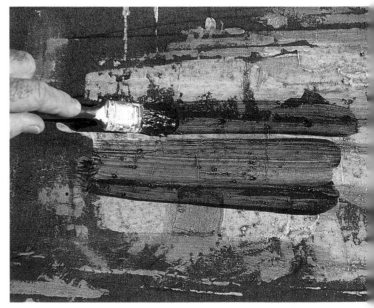

B. Applying a transparent blue oil glaze over the first glaze of red.

C. Example of textured ground, glazing, and opaque paint handling found in upper section of *As Night Climbs the Escarpment* (over).

D. Example of effects found in lower section of *As Night Climbs the Escarpment* (over).

OIL PAINTS

Brendon Darby, *As Night Climbs the Escarpment,* oil and mixed media on canvas, 36 × 54" (91.4 × 137.2 cm).

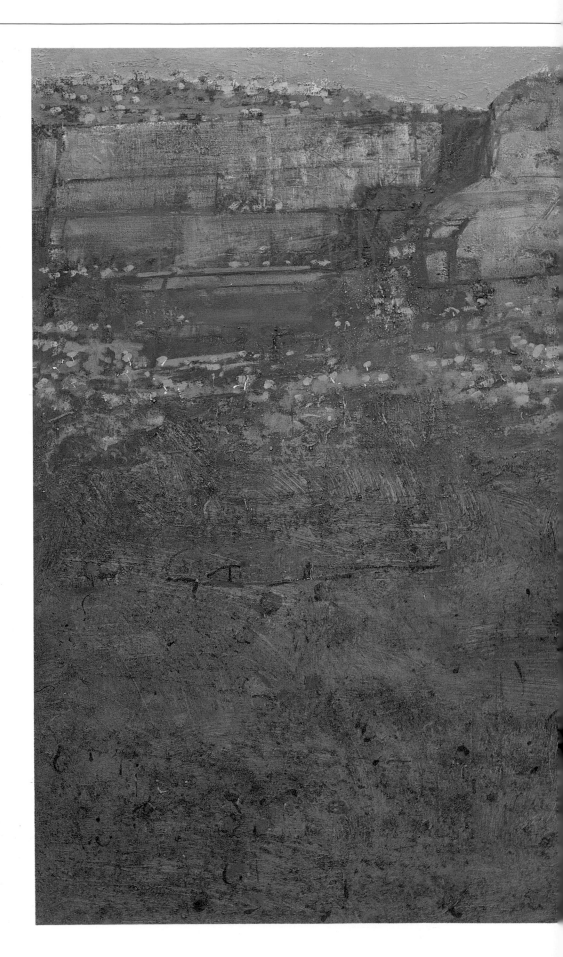

OIL PAINTS

▰▰▰ DABBING WITH A TISSUE

To create the texture shown at right, I simply applied two thin color washes to the canvas, then dabbed the wet surface with a crumpled up tissue. This technique is useful for backgrounds and for suggesting patterns on clothing.

▰▰▰ MONOPRINTING A RANDOM PATTERN

To monoprint with oils, you need a piece of glass, acetate, or melamine as a working surface. For the example shown below, I diluted my oil paints with a little turpentine and randomly spread the thinned colors—in the first stage, orange and green—on my glass surface. I then took a print: I placed a sheet of paper on top of the color and rubbed the back of the sheet with my hand, then pulled it off the glass. When the paper was dry, I printed it a second time using thinned blue oil paint. I might work up a monoprint like this one to a more finished stage with oil pastels.

MONOPRINTING A PLANNED DESIGN

In making this monoprint of a sunflower I took a more deliberate approach, placing a drawing under my glass working surface as a guide. I thinned the oil paints with turpentine and used a brush to paint the design, following my drawing. I placed a sheet of glossy paper on top of the paint and rubbed the back of it with my hand, then lifted the paper off to get this print. As there was still paint left on the glass, I was able to take a second print.

First print.

Second print.

OIL PAINTS

■ MARBLING WITH OILS

To marble with oils—which is often a good way to start a painting—mix oil paint with turpentine to a runny consistency in an old tin or jar. Fill a flat, shallow container with water and, after it has settled, pour the thinned paint onto the water's surface. With a stick or feather, move the paint into a pattern that you like and place a sheet of paper over it to take a print. You can mix several colors together and take a print, or print one color, let it dry, print another color over the first, and so on. The marbling process works well on drawing paper, oil painting paper, and slick, glossy papers. In example A, I mixed two colors on the water's surface, took a print, and then added the trees with an oil pastel. In example B, the treelike image that accidentally emerged led me to add a few small branches with an oil pastel. The little bits of blue are the result of paint that remained on the water's surface from a previous printing. (Newspaper can be used to remove color from the water.) In example C, opposite, I applied masking fluid to the paper where I didn't want color to go; I wanted only the hill to be marbled so that I would have a nice texture showing through my subsequent work. Example D illustrates how marbling looks on colored paper, in this case a pale gray. Don't overlook the possibility of creating interesting backgrounds for paintings this way.

A. Marbling with two colors; the trees were done with oil pastel.

B. Marbling with one color; the blue was picked up from a previous printing.

C. White areas were masked off with masking fluid prior to marbling.

D. Marbling on colored paper.

OIL PAINTS

■ CARVING INTO HARDBOARD

Garry Berchmans Smith has developed a most unusual and rewarding method of painting on hardboard that he first carves. Smith composes his paintings as he goes along. He first draws on his board, then cuts the dominant rhythm with a Stanley or similar knife. He next finds a secondary rhythm to harmonize with the first, and so on, until he finds the right degree of complexity and interwoven rhythms. The next step is to cut away the background area with a flat chisel, which is also used for any surface shaping, such as the feathers on the birds in his painting *Symbol*. He generally uses a deep ∨ cut, but in some places he uses a single cut, which causes the board to rise on the undercut. When all the carving has been completed, the board is given a primer of thin white acrylic paint and left to dry. Next, Smith applies a thin layer of oil color, letting it run into the carving in varying densities and using it to emphasize the areas he wishes to bring out. When this layer is dry, he continues to work over the surface with more solid color, and leaves this to dry. When the painting is complete, he applies a final coat of high gloss, nonyellowing acrylic Paraloid varnish, which picks up the light on the carved edges and adds a glow to the work. (The gloss finish can be modified if so desired by diluting the varnish with mineral turpentine.) Using his carving method, he seeks by means of rhythm and glow to transform the mundane and prosaic into poetry and song.

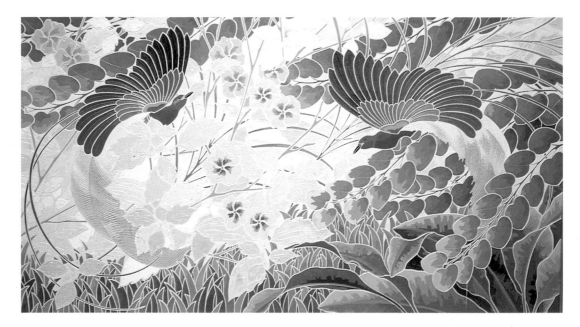

Garry Berchmans Smith, *Symbol,* oil on hardboard, 30 × 54" (76.2 × 137.2 cm).

Garry Berchmans Smith, *Abstract,* oil on hardboard, 24 × 36" (61 × 91.4 cm).

Leonid Zuks, *Balingup Tavern,* oil on canvas, 24 × 32" (61 × 81.3 cm).

■■■ PAINTING WITH A SYRINGE

Taking an almost improvisational approach, Leonid Zuks employed a variety of unusual implements in creating the painting at right. He made a preliminary drawing on the canvas, then, with tape, masked off the main subject, a tavern. He painted in the background and parts of the foreground at the base of the building, then removed the tape and painted the building. As he began to work on the foreground, the joy of spontaneous creativity took over. Applying paint with wide brushes and trowels allowed Zuks to lose elements of realism. As the excitement continued to build, he worked with different tools to bring the painting to completion. He filled a syringe with paint straight from the tube and squirted it onto his painting, guided only by the flow of line and color that began to emerge as the work progressed. He applied more colors, using a different syringe for each. Finally, he flicked thin paint over the composition to indicate small flowers.

■■■ WORKING IN ALKYDS

Alkyd-based paints are a boon for those who want the look of oil paints without the long drying time between coats. They are fully compatible with oil paints and are superb for glazing when thinned down with Liquin. Alkyds can be used on canvas, canvas boards, hardboard, Plexiglas, and paper primed with gesso. Ruth Croft-Firman executed this example on Laminex, a laminated wood product that comes under different trade names but is mainly used in the making of bench tops. Off-cuts are the cheapest way to buy this material, which cuts and snaps easily into pieces of different sizes. When she paints on this surface, Croft-Firman takes her lead from its wood-grain pattern, including some of the color and tone of the Laminex in her paint color mixes to ensure harmony with the background. In this case the Laminex was a pale ochre color, some of which the artist allowed to show through the painting. This small impression of a Western Australian Christmas tree, executed with single strokes of the palette knife, was dry and ready for framing in three days.

Ruth Croft-Firman, *Christmas Tree Glory,* alkyd on Laminex, 8 × 6" (20.3 × 15.2 cm).

OIL PAINTS

■ PAINTING ON A CIBACHROME

Marjorie Bussey found inspiration in a Cibachrome photograph and used it as a support for the oil painting shown at right. She obliterated some of the elements in the photo and, through free association, built images that had to do with bones, shells, twigs, the earth, sun, moon, and the like. So that the oil paint would bond to the Cibachrome, she first coated the photograph with acrylic paint. Next, she collaged on tissue paper and sealed her painting surface with acrylic gel medium. Bussey then applied gold and silver pencil together with gold and silver inks, followed by black, white, and gold oil paint and oil stick. Other colors included pink, yellow, and red oil glazes. When all was dry, she crushed blackboy resin (an extract of the grass tree, a plant of the genus *Xanthorrhoea*, native to Australia) and dissolved it in mineral spirits. This reddish-brown resin was then applied to parts of the painting, intensifying the colors underneath.

Marjorie Bussey, *Australia in Spring,* mixed media on Cibachrome, 47 × 65" (120 × 166 cm).

■ USING OILS ON PLASTER RELIEF

In this unusual approach, John Chescoe first created an image of his subject in plaster relief, then colored it with a succession of oil glazes. He mixed Polyfilla (spackling compound), water, and PVA glue to the consistency of marzipan and applied it to the smooth side of a piece of Masonite using a palette knife to get the desired relief shape. While the plaster was wet, he textured it with various tools, including a hair roller, which was perfect for suggesting the fish-scale texture of the soldiers' armor. Once the plaster hardens it is possible to add further detail, primarily with a pocket knife. At this stage Chescoe left the work to harden and cure for a few days. Next, he applied two coats of tinted acrylic paint, adding a third and final coat tinted with the color he wanted to show through in the finished painting. This acrylic base sealed the plaster, preventing the subsequent oil glazes from sinking into it. When the acrylic was completely dry, the artist applied a glaze of oil paint over the whole relief and left it for approximately ten minutes. He then wiped off surplus paint with a cotton rag. The glaze that settled into the recessed areas of the hardened plaster resulted in subtle shading effects, the variation of lights and darks depending on how much pressure was applied with the rag. The final application of color, including highlights, took place when the oil glaze was completely dry.

John R. Chescoe, *The Long Boat,* mixed media on plaster, 24 × 36" (61 × 91.4 cm).

▰▰▰ COLLAGING WITH HYDROSEAL AND GOLD LEAF

Elizabeth Ford found the inspiration for this painting in a Florentine fresco depicting Saint Francis preaching to the birds. The work, with its matte, tarnished, worn surface, involved many layers of underpainting, texturing, staining, and glazing, as well as the use of gold leaf, the evidence of which can be seen only in very small flecks. Ford began this painting by applying heavy-grade Hydroseal (a bitumen-based sealant used for waterproofing pipes) to stretched primed canvas, embedding a frayed, rectangular piece of printed cotton fabric in the lower half of the work. To establish the bird motif on the fabric, she rolled Hydroseal through a paper stencil with a small foam roller. Next, she covered the remaining ground with generous amounts of oil paint and Hydroseal, and, with a sharpened sliver of wood, incised and gouged lines and patterns into the thick surface. Ford then allowed the painting to dry for several months. Resuming work, she applied several layers of oil glazes, using gold leaf between these layers. The final layers of color and detail were achieved with oil paint mixed with Win-Gel to form a more durable surface and to prevent cracking. The gritty, crusty-textured, duck's-egg blue paint at the top of the painting was made with a mixture of beach sand and impasto medium. The black bird motif was emphasized by scumbling a pale, rusty peach color into the surrounding ground. A matte wax varnish was applied to the completed work.

Elizabeth Ford,
Tuscan Fragment,
mixed media on
canvas, 10 × 8"
(25.4 × 20.3 cm)

OIL STICKS

Oil sticks make it possible to draw and paint at the same time and are unintimidating to work with. You can use them alone or in combination with various oil painting mediums to achieve both graphic and painterly effects, and they are especially convenient for working in the field. Shown here is just a smattering of the possibilities.

◼ DRAWING WITH OIL STICKS

An oil stick can be handled like a drawing instrument when you want to take a graphic approach, as in the example at right.

◼ SUPERIMPOSING LINES ON FLAT COLOR

Illustrated below is one way to combine drawing and painting effects; the black lines were simply drawn over the flat field of red color.

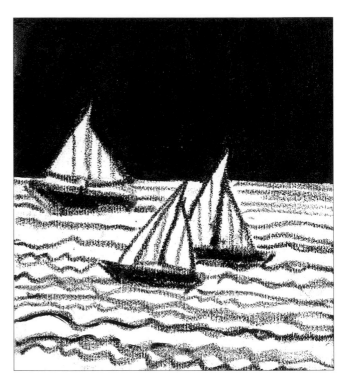

■ COMBINING OIL STICK WITH OIL PASTEL

The difference between oil sticks and oil pastels is slight—oil sticks contain more oil and wax, giving them a very buttery feel; they also contain driers, which oil pastels do not. Not surprisingly, since both mediums are oil-based, they work well together. Both can also be diluted with turpentine or Liquin. In the example at left, I combined black oil stick with coral oil pastel.

■ USING LIQUIN

To create the effect shown below, I dipped an oil stick in Liquin, then drew with it. Used this way, the oil stick has a nice slippery feel to it.

OIL STICKS

■■■ BLENDING MULTIPLE COLORS
With oil sticks, you can easily mix colors directly on your painting surface. At right, I put down the three primary colors side by side on a piece of canvas and blended them with a colorless blender, creating the secondary hues orange and green.

■■■ GLAZING WITH A COLORLESS BLENDER
Below, I established a square of color with an oil stick on a piece of primed canvas and, with a colorless blender, pulled paint out, making it progressively lighter till it takes on the quality of a glaze.

▰▰ SCRAPING OUT COLOR

At left, to introduce some contrast in a flat field of color, I scraped away some of the paint to reveal the canvas texture.

▰▰ EXPERIMENTING WITH SGRAFFITO

Using sgraffito techniques with oil sticks can give you some interesting effects. In the example at left below, I laid down a square of yellow paint and laid a square of red on top of it. I then scratched into the red paint to reveal the yellow underlayer.

▰▰ APPLYING OLEOPASTO

To achieve the effect shown at right below, I drew a random line pattern on a piece of canvas with an oil stick, then, with a palette knife, dragged Oleopasto over it. This picked up some of the color to give a glazed effect but still left the lines visible.

OIL STICKS

■ ACHIEVING WASH EFFECTS

As with oil paints, you can thin oil stick color with
turpentine to get watercolorlike effects, as the
example at top right shows.

■ MIXING COLOR ON A PALETTE

Although with oil sticks it's more common to mix
colors directly on your painting surface, you can,
in fact, mix two or more colors on a palette. For the
two examples shown at center, I mixed yellow and
black to make a green, which I then applied to the
canvas with a brush and turpentine.

■ MONOPRINTING

It's possible to monoprint with oil sticks; to create
the very simple example shown below, I applied a
little Liquin to a sheet of glass and drew on it with
a few colors. I then placed a piece of oil painting
paper over the drawing and rubbed the back of it
with a roller (the bowl of a spoon would also work
for this) to transfer the image. More traditional
ways of monoprinting with a press are also possible.

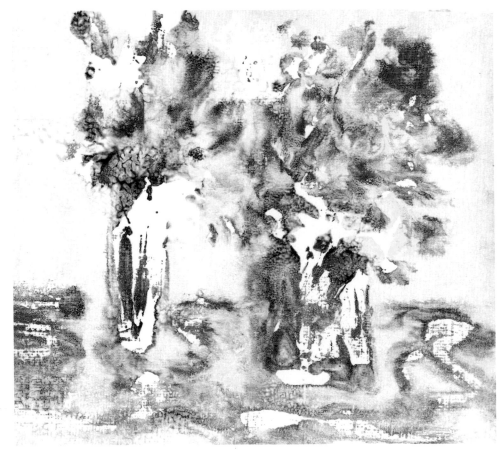

CREATING IMPASTO EFFECTS

You can easily achieve impasto textures with oil sticks. Here at left, I squeezed some Oleopasto onto my palette and rubbed the oil stick into it. I then applied this mixture to a piece of canvas with a palette knife.

PAINTING CLOUDS

Clouds are so easy to do. In the example shown below, I applied a thin wash of color for the sky and then worked back into this with a white oil stick, finishing off with a colorless blender to soften the edges of the cloud.

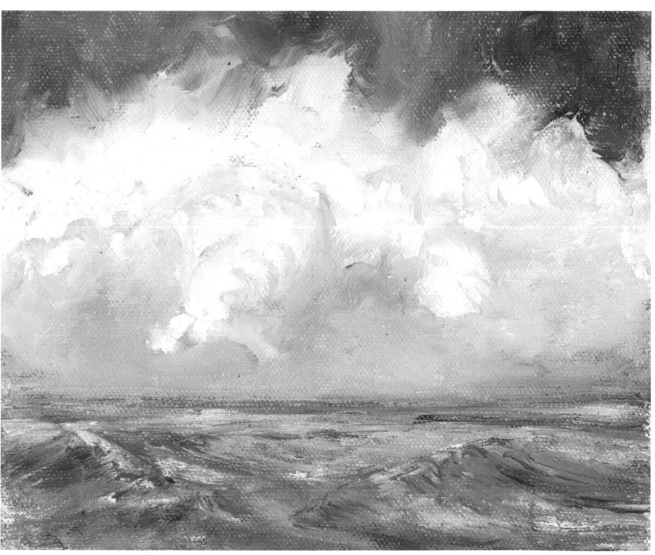

OIL STICKS

■ TEXTURING WITH SAND

For textural interest, I applied sand to watercolor paper, gluing it in place with acrylic matte medium. In the example at right, I laid in a wash of acrylic paint and let it dry, then scumbled over the sand with an oil stick. Shown below is a more finished work; I used oil sticks to paint the landscape elements over an acrylic wash.

■■■■ *INCORPORATING OIL STICKS IN COLLAGE*

This experimental piece by Laura Cole, measuring 20 × 16" (50.8 × 40.6 cm), was the catalyst for a much larger finished work. To create it, she tore and cut pages from magazines and pasted them onto a plain black ground. She then applied oil sticks and oil pastels in a scribbly fashion, mindful of the direction of her strokes. Cole scratched back into the oil color with a compass point and softened some edges using turpentine and a brush.

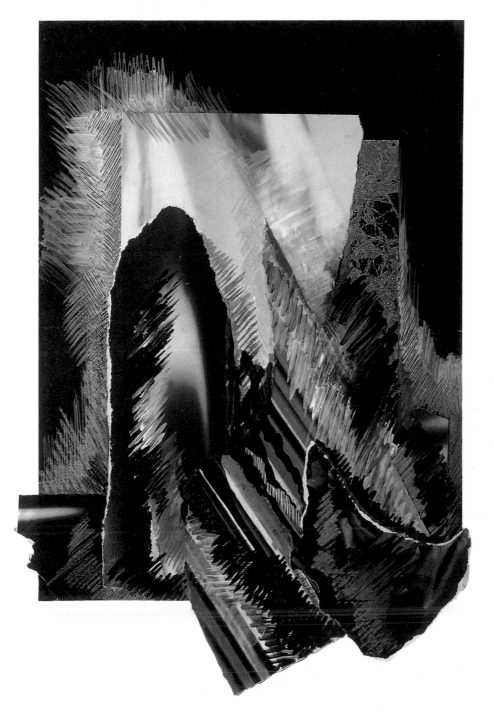

ENCAUSTIC

In encaustic painting, colors are made by mixing pigment with melted wax and sometimes varnish. They are liquid when heated but solidify quickly away from heat. You can easily make encaustic colors by mixing melted wax crayons with melted beeswax. As described in the introduction to this chapter, in the basic process, you apply a layer of uncolored melted wax to your canvas or board, then paint the hot wax colors onto this surface. When the painting is complete, heat is applied to fuse the colors; then, once the surface has solidified again, you can polish it with a soft rag. There are many variations of this technique; don't be afraid to explore.

▬▬ SPRINKLING ON POWDERED PIGMENT

In the example shown above, I first coated my painting surface—a piece of primed canvas—with a layer of white beeswax, which I melted in a saucepan, making sure not to let it get hot enough to smoke. Once applied, the wax solidified in seconds. I then melted a blue crayon and, with a brush, painted this on top of the beeswax. When this was dry, I used a heat lamp to fuse the blue crayon into the white beeswax base. As I did so, I sprinkled on some gold powdered pigment. When all was fused and dry (this took about five minutes), I buffed the surface to a high sheen with a soft cloth.

▬▬ INCISING LINE WORK

As always, for the example at right, I first coated my painting surface with melted beeswax, then melted a gold crayon and fused this into the wax layer with the heat lamp. When this had solidified, I added two more colors and fused them to the surface. While the color and wax was still in a melted state, I drew into it with a toothpick.

TEXTURING WITH GAUZE

I followed the basic encaustic procedure for the example at right except that just before fusing the color to the wax base, I placed a piece of gauze on the surface. When all was solidified, I removed the gauze to reveal a textured surface. You could, of course, leave the gauze on as a collage element if so desired.

APPLYING ENCAUSTIC OVER ACRYLIC

Below, I used the encaustic technique over an acrylic base in only selected areas to get a contrasting effect. First I painted a wash of orange acrylic on my canvas and let it dry. Then I covered part of the canvas with melted beeswax, and when it was dry, sprinkled on some powdered charcoal, fusing it to the surface with a heat lamp. Over this I added some melted blue crayon and fused it with the charcoal. Finally, I polished the surface with a soft cloth. The areas of the canvas where no wax was applied work well with the contrasting polished surface.

ENCAUSTIC

◼️ *EXPERIMENTING WITH HEAT EFFECTS*

To get the effect at right, I mixed some powdered burnt sienna pigment and a little damar varnish with melted beeswax and painted this onto a piece of primed canvas. Then I applied melted green crayon to this surface and fused it with a heat lamp. By holding the lamp too close to the surface I accidentally applied too much heat, which caused the green crayon to separate, resulting in a mottled effect.

◼️ *GRATING COLOR ONTO WAX*

Below, after coloring my background with acrylic paint, I covered it with a layer of melted beeswax. I then grated wax crayons onto the surface and placed this under the heat lamp to fuse the colors to the ground. The result was a combination of rough and smooth textures.

◼◼◼ TEXTURING WITH SAND

For the example at left, I coated a piece of canvas with a layer of melted beeswax, adding some fine white sand to get a textured look. When this was set, I applied melted crayons to the surface and, using the heat lamp, merged the colors. I then scumbled over the top with an iridescent oil pastel and fused this with the rest of the colors. A final polish with a soft rag gave the surface a wonderful glow.

◼◼◼ VARYING THE ENCAUSTIC TECHNIQUE

Paul Hinchliffe calls the technique he used for the work shown at left below "poor man's encaustic." The process is not true encaustic because no heat is applied, but it nevertheless results in effects that are similar in appearance to those achieved with more traditional methods. The wax medium Hinchliffe used here is a combination of paraffin and carnaubo waxes mixed with silicone and mineral spirits. It is produced commercially as a furniture wax and is widely available. The artist began *Red Postcard* by taping a blank postcard to his working surface, masking off all four edges so that when finished, the work would have a distinctive white border. He then applied various layers of oil pastel to the postcard, working small amounts of wax medium across each one with his fingertips (it's best to wear gloves to do this). The waxy surface dries in a minute. Wood ash was then sprinkled over the surface and smeared into the colored wax ground, the irregular ash particles making unpredictable marks. The linear motif was scratched into the work with a compass point. Finally, the surface was sprayed with a fine mist of water and then lightly buffed with a cotton rag, giving the work a high-gloss finish.

Paul Hinchliffe, *Red Postcard*, wax, oil pastel, and ash on card, 5³/₄ × 4¹/₂" (14.6 × 10.5 cm).

PASTELS

Pastel is a very expressive medium that is enjoying a renaissance worldwide, led by some American artists who are doing large and innovative works. Its ancestors are the red and white chalk and charcoal such artists as Leonardo da Vinci and Michelangelo used in the fifteenth and sixteenth centuries to create numerous beautiful drawings. By the nineteenth century, a much wider range of colors had evolved, and in the hands of the Impressionists, particularly Edgar Degas, pastel became extremely popular as a major medium. One of the most important reasons for its popularity is its directness; with pastel, you can draw and paint spontaneously with pure color. Pastels are quick to apply and involve virtually no preparation time and no waiting for stages to dry before moving on. They are also easy to transport, don't require much equipment, and entail no messy cleanup. Pastels won't crack or fade the way oil paint can over time; works by eighteenth-century pastelists are still as fresh today as the day they were executed.

The two main types of pastel considered here are chalk pastels (which comprise soft pastels, hard pastels, and pastel pencils) and oil pastels. Oil pastels have a much shorter history than chalk pastels, as they did not appear until the 1920s. Also mentioned in this chapter are ways to use charcoal and powdered pigments in pastel-like ways.

■■■■ CHALK PASTELS

Soft chalk pastels are made from pure powdered pigment bound with just enough gum tragacanth (sometimes with clay or chalk added) to prevent them from crumbling. They are available in a huge color range, chiefly because you cannot mix colors on a palette the way you would when working with oil, watercolor, or acrylic paints. Most brands are cylindrical and come in paper wrappers; others are rectangular. Besides average-size sticks that measure around 2½ to 3 inches in length, there are small half sticks as well as giant-size pastels for laying in large blocks of color. Soft pastels are available as individual sticks and in boxed sets that contain anywhere from a dozen to several hundred colors. There are many brands of pastels on the market, each with its unique qualities. Professional-grade, artists'-quality pastels give better results than student-grade pastels and consequently are more expensive, but generally speaking, you get what you pay for. Choosing the type that suits you is a personal matter. Well-known brands include Sennelier, Rembrandt, Rowney, Holbein, Grumbacher, and Schmincke.

Hard pastels are firmer than soft pastels and are thus good for drawing, sketching, and detail work. Two well-known brands are Conté and NuPastel. Pastel pencils are simply hard pastels in pencil form. They can be sharpened to produce fine, precise lines and are excellent for detail work, and they don't dirty your hands. Well-known brands are Carb-Othello and Conté.

Pastels can be applied in both linear and painterly ways, including crosshatching, feathering, pointillism, scumbling, stippling, and blending. Colors can be smudged and softly blended together or laid down one atop another in bold, unblended strokes. And, because soft pastels are water-soluble, you can even create wash effects by going over passages with a damp paintbrush.

For blending colors, especially in small areas where your fingers or tissues would be awkward, tortillons and stumps come in handy; these are cylinders of soft, rolled paper with pointed tips. Another essential is fixative, a weak varnish solution that is sprayed on pastel work to help the pigment particles adhere to the painting surface. There are two kinds, workable and final. Workable fixative is called for when you need to add more pastel color to a passage but the buildup of pigment is so great that it begins to flake off. A spray of fixative isolates the pastel layer and restores "tooth" to the surface so you can continue to add color. Final fixative is used to protect finished works from smearing and smudging. Both kinds darken pastel color to some degree. For erasing mistakes, lightening a color, or pulling out highlights, a soft, kneaded eraser is a good tool. Blue tack can also be used as an eraser, as well as for cleaning your hands and dirty pastel sticks. A hard plastic eraser is handy for creating highlights and sharp lines.

The most popular surface for pastel work is paper specially made for this medium, such as Canson Mi-Teintes, which has the "tooth"—tiny hills and valleys—needed to hold the particles of pastel. Watercolor papers, particularly the rough and cold-pressed surfaces, can also be used with pastel; the hot-pressed surface and other smooth papers are best suited to fine linear drawings, since they lack sufficient tooth to hold much pigment buildup.

Some artists prefer fine-grit sanded pastel papers, which can hold a lot of pigment. Besides surface texture, you need to consider the color and value of the ground you choose, since these factors will affect the look of all the pastel colors you apply to it.

Even treated with fixative, pastel paintings are subject to damage unless you take precautions. To ensure permanence, frame them behind glass using only acid-free, archival-quality mats and backings.

Keeping your pastels clean and your work area free from pastel dust can be a problem. It's a good idea to keep your pastels in a container lined with a layer of rice. Some people arrange their pastels in the grooves of a sheet of corrugated cardboard; you will no doubt devise your own system. Then there are people like me who work with no system at all!

■■■ OIL PASTELS

Oil pastels are a combination of pigment, oil, and wax molded into crayon form. In general they contain less oil and wax than oil sticks and thus have a less greasy, slippery feel, although the difference between the two mediums has blurred of late. The more important distinction is that oil sticks contain driers, meaning the paint will dry to a hard film in just a few days, whereas most brands of oil pastel may never truly dry or may take years to do so.

Oil pastels vary widely from brand to brand in texture and handling characteristics; some are hard and waxy, others soft and greasy, and some are more opaque than others. Each type has its advantages. As with chalk pastels, oil pastels may be cylindrical or rectangular and come in a range of sizes from giant to small, the median being sticks that measure about 2½ to 3 inches long. You can buy them in boxed sets or from open stock.

One of the great features of oil pastels is that, unlike soft chalk pastels, they are dustless; they also don't break as readily or crumble, and can be used on virtually any surface. These include papers used for drawing, chalk pastel, or watercolor; there are also some wonderful handmade papers available that oil pastels can look quite stunning on.

Until very recently, oil pastels were not taken seriously as a painting medium, and consequently little has been written about them. Filling the gap are Kenneth Leslie's comprehensive book *Oil Pastel* (1990), and *The Pastel Book* by Bill Creevy (1991), both published by Watson-Guptill.

MATERIALS, TOOLS, AND TECHNIQUES TO TRY WITH PASTELS

WITH CHALK PASTELS:
- water
- fixative
- mineral spirits
- acrylic gel medium
- acrylic modeling paste
- acrylic paints
- gouache
- inks
- metallic colors
- pencil
- Conté crayon
- charcoal
- powdered pigments
- ash
- Hydroseal
- colored papers
- Japanese papers
- tissue paper
- pastel board
- blending
- scumbling
- feathering
- stenciling
- rubbing
- color layering
- color lifting

WITH OIL PASTELS:
- turpentine
- Oleopasto
- acrylic paints
- inks
- edicol dyes
- metallic colors
- iridescent colors
- sand
- crumpled paper
- dark paper
- heat
- monoprinting
- scraping back
- sgraffito
- frottage
- collage

CHALK PASTELS

Chalk pastels can be applied in both graphic and painterly ways, and can be combined innovatively with a host of materials for some beautiful, sensuous effects. All it takes is your imagination.

◼◼◼ MAKING BROAD STROKES

To make broad marks as shown at top right, hold the pastel on its side and, using its full width, drag it across the paper. Vary the pressure for different effects.

◼◼◼ SCUMBLING

With this technique, you hold a soft pastel on its side to apply very light strokes of color over another without completely covering it. At center right, I scumbled one gray over another, revealing the texture and color of the red paper.

◼◼◼ MAKING RECTANGULAR STROKES

I made the marks at bottom left with the end of a rectangular pastel held flat against the paper.

◼◼◼ CREATING A BASKET-WEAVE EFFECT

I established the pattern at bottom right using the pastel stick two different ways. I made wide strokes using the pastel on its side, then crossed diagonal strokes over them with the tip.

EXPLORING POINTILLIST STROKES

Pointillism means painting with dots—regular, geometric spots of color—placed to create the effect of optical mixture. To make the fairly large dots in the example at top right, I used rectangular pastels, placing the end of each stick flat against the paper and twisting it. For the second example at right, I again used rectangular pastels, this time working with the sharp edge of each stick to get tiny dots.

LETTING STROKES BLEND THEMSELVES

With pastel, you don't mix color on a palette but on your painting surface. In the approach illustrated at top below, I simply laid strokes of one color over another and let the different hues blend themselves. This is a good way to maintain textural interest and a vibrant quality in your work.

BLENDING WITH A STUMP

Another way to mix color in pastel is to place two or more hues near each other on your painting surface and blend them with your finger or a stump, tissue, or other tool. In the bottom example I laid down blue next to yellow and rubbed the colors together with a stump to create green.

CHALK PASTELS

STROKING LIGHT OVER DARK

Because pastel is an opaque medium, you can create some wonderful, shimmering effects by scumbling a light color over a dark one, as shown at top left. This is a good way to break up large, potentially monotonous passages in a painting.

STROKING DARK OVER LIGHT

It's also possible to do the reverse—to stroke a dark color over a light one, which gives a different effect, as shown at center left.

FEATHERING

Feathering, illustrated at left below, is very useful when you need to rescue a pastel passage that has been overly blended and gone flat. In this technique, you lightly stroke pastel color over the chosen area in thin, diagonal parallel lines. Feathering is also a good way to modify an underlying color. For example, if a green passage looks too cold, you can warm it up by feathering over it with its complement, a red.

CREATING WASH EFFECTS

Soft pastels work beautifully with various solvents, including mineral spirits. This means you can create wash effects or control pastel color more like liquid paints. Below, I applied a broad swath of red pastel to green pastel paper and brushed over half of it with mineral spirits. Note how the color filled in the paper's tooth.

COLOR LAYERING

At top right, I applied one color on top of another so that they blend visually. First I laid down a blue, then I stroked a red over it, creating a violet.

COMPARING BROKEN AND BLENDED COLOR

In the example at center right, I applied two colors to smooth watercolor paper with no physical blending. Note how the white of the paper shows through, giving a broken effect. In the example at bottom right, I blended the same two pastel colors with a soft brush, creating a smooth, flat passage of mauve. Each of these two effects has its uses in pastel painting.

BRUSHING PASTEL WITH WATER

The fact that soft pastels are soluble in water means you can easily achieve wash effects that have the look of watercolor. Below, I applied burnt sienna and ultramarine blue to part of my paper, and then, with a paintbrush dipped in water, pulled some of the color out to resemble water.

CHALK PASTELS

▬▬ RUBBING FOR SOFT, SMOOTH EFFECTS

Jeremy Kirwan-Ward achieved the extremely subtle color and value transitions in the work at right by rubbing the pastel with his fingers and with cotton wool. To create dense passages, he applies the pastel fairly randomly on his paper, then spreads the color by rubbing it with his fingertips. This leaves a fair amount of pastel dust on the paper's surface, which can be worked into with other colors or partially removed with cotton wool to create a more transparent, stained-looking area. Densely applied pastel rapidly fills up the paper's tooth, making it difficult to add more, but areas where some of the color has been removed can be worked over for a longer period before the tooth is lost. Kirwan-Ward sometimes also uses cotton wool to apply color. He rubs a pastel stick on fine sandpaper, reducing it to dust, then dips cotton wool into the dust and rubs it onto the surface of his paper. This produces a pale tint that can be spread evenly over a large area, leaving virtually no surface dust. These rubbing techniques provide a wonderful surface on which to build color in layers.

▬▬ PREPARING AN UNUSUAL GROUND

In developing this painting, Mary Knott worked with Hydroseal, a bitumen-based sealant that is used to waterproof pipes and is available in hardware stores. It can be diluted with turpentine to a paintlike consistency.

Working on heavy paper, Knott defined the basic shape of the image with acrylic gesso, sometimes incorporating plaster dust. When the gesso was completely dry, she applied a mixture of Hydroseal and turpentine over this ground, allowing it to penetrate the surface. With turpentine, she then wiped back the coating of Hydroseal thoroughly to reveal lightly stained areas of gesso. Once the artist achieved the desired intensity of tone, she burnished the surface with a clean cloth to remove surplus bitumen. After allowing her prepared ground to dry for several days, Knott then applied soft pastel, rubbing in color with her fingertips and palm. She began with lighter shades and progressed toward the darks, applying a workable fixative to each layer of pastel. Knott continued working in layers this way until she achieved a satisfactory surface.

Jeremy Kirwan-Ward, *Spaced in II*, pastel on paper, 28³/₄ × 19" (73 × 48 cm).

Mary Knott, *Choices*, pastel, Hydroseal, gesso, and plaster on paper, 40 × 39¹/₂" (102 × 100 cm).

USING CONTÉ CRAYON AND MINERAL SPIRITS

Peter Walker executed these two still lifes by combining Conté crayon with soft pastels and mineral spirits. On paper of a middle value, he first established the details of each composition with Conté crayon (which affords a lot of control when you're drawing) and then applied a light spray of fixative. Next, he built up color in soft pastel, working from light to dark. He went over selected areas and defined small details with a brush dipped in mineral spirits, which readily dissolves the pastel so you can move it around like paint and dries much quicker than water. Note in particular the blue-and-white vase in the top painting, where this method was used. To keep the pastel looking fresh, this artist does not spray fixative on his works after the final application of color.

Peter Walker, *Blue Vase*, pastel on paper, 30 × 22" (76.2 × 55.9 cm).

Peter Walker, *Still Life with Lemons*, pastel on paper, 22 × 30" (55.9 × 76.2 cm).

CHALK PASTELS

■■■ PAINTING ON PASTEL BOARD

For this painting, Greg Baker selected pastel board in a dark green that would serve as a compatible ground for his rendering of the water, as he planned to leave a lot of the board's color to show through. Baker likes the rigidity of this support, which essentially consists of pastel paper mounted on an acid-free board. Here, he used a pastel board made by Crescent; such boards are available in large sizes and are easy to cut if smaller pieces are required.

Baker began with a simple sketch of his subject, leaving detailing until later. Holding the soft pastel sticks sideways, he stroked on color in and around his sketch, starting with the lighter tones of the composition. As he painted the water, he let the dark green ground color show through as a middle-dark value. After each stage of overall pastel application, the artist sprayed fixative over the entire painting. Fixative deepens the value of colors, so when you apply the same color over an area that has been fixed, it appears lighter, resulting in subtle highlights. As Baker continued working, he concentrated on developing the details of the buildings and boats. He finished the painting with a light spray of fixative.

Gregory John Baker, *Dancing,* pastel on Crescent pastel board, 30 × 40" (76.2 × 101.6 cm).

Pastel applied to Chiri paper.

■ *EXPLOITING PAPER TEXTURE*

One of the chief characteristics of soft pastels is that perhaps more than any other painting medium, they reveal the nature of the surface you apply them to. Japanese papers, with their fascinating array of textures, can give some interesting results when pastel is applied to them. For the example shown at left, I worked on Chiri paper. I like the way the pieces of bark in the paper are in harmony with the trees. For the example shown below, I scumbled pastel on Washi paper, which emphasized its long fibers. It can be fun to look for shapes in such textures to develop further with drawing.

Pastel applied to Washi paper.

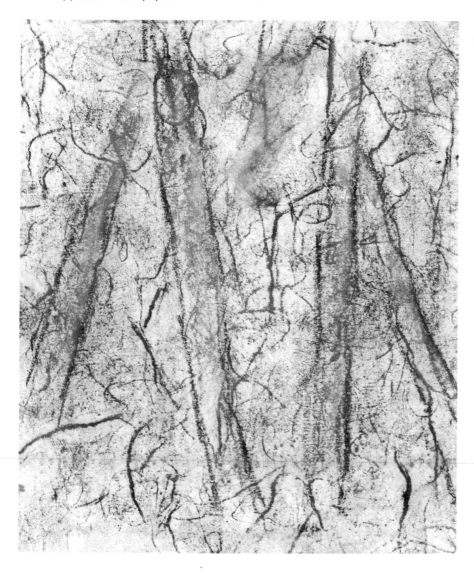

CHALK PASTELS

DUSTING COLOR ONTO WET PAPER

With the dusting technique, you can achieve lovely, delicate veils of color. Essentially, you scrape pastel sticks to deposit the particles of color on your painting surface, fixing the dust by various means. In the example at top right, I puddled water on a piece of smooth watercolor paper. Then, holding the sticks over this surface and using a Stanley knife, I scraped pastel colors into the water and let them blend. I left this to dry before applying fixative.

DUSTING COLOR ONTO FIXATIVE

In the second example at right, I sprayed the paper thoroughly with fixative, and while it was still damp, I scraped two pastel colors over the surface. The colors bled slightly, resulting in an unexpected effect. With this approach, you do not have to reapply fixative after depositing the color.

DUSTING ONTO GEL MEDIUM

Illustrated third from the top is another variation of the dusting technique. I brushed a mixture of equal parts water and acrylic gel medium onto my paper first, then scraped pastel color over the surface. I sprayed on fixative once it was dry.

SPRAYING FIXATIVE ON A DAMP SURFACE

For the bottom example, as in the preceding one, I brushed gel medium mixed with water onto my paper and deposited pastel dust on it. But instead of waiting for the surface to dry, I sprayed on fixative while the gel was still damp, letting everything run and merge. This gave the pastel an unusual look.

▰▰ DUSTING WITH IRIDESCENT COLORS

Among the vast array of soft pastel colors available from the French manufacturer Sennelier are iridescent hues. Here at left, I dusted iridescent blue, green, and silver pastel onto black paper, creating the effect of a starry nighttime sky.

▰▰ USING DRY PIGMENTS AND CHARCOAL

Dry (powdered) pigments and powdered charcoal can yield effects similar to those achieved with the pastel dusting technique. You can also create textural washes with them. Here, I randomly applied charcoal and powdered pigments to my paper, then rinsed off the excess under the tap until I got a satisfactory shape. When this was dry, I applied workable fixative, then delineated the boulder shape with a charcoal pencil.

CHALK PASTELS

▰ *EXPERIMENTING WITH DRY PIGMENTS*

Ruth Croft-Firman created the paintings shown on these two pages by working with pure, powdered pigments and gum arabic, the binder used in watercolor paints. To get effects like these, she applies tape around the edges of her watercolor paper, sprays it with water back and front, and lays it on a wet, waterproof surface. After wiping the paper until the surface looks velvety, she brushes on an overall coat of gum arabic, which makes the dry pigments adhere to the paper. (Acrylic or other adhesive mediums can be used in place of the gum arabic.)

Using a tiny salt spoon, Croft-Firman carefully spoons powdered pigments out of their jars and into a small, fine sieve (an inexpensive tea strainer). She stirs the powder lightly to mix her colors while moving the sieve over the damp paper, depositing pigment where she wants it and leaving some of the white paper uncovered. This calls for skill and a steady hand, as large amounts of pigment tend to fall in blobs. As the artist explains, if the paper dries too quickly during a painting session, it can be sprayed with water from underneath.

To create subtle tones, Croft-Firman adds titanium white or black pigment to her color mixes. Sometimes she uses silver, gold, or bronze pigments either alone or within a color mix when she feels they will express an aspect she wants to include; in both of these paintings, she used silver pigment. As she develops a work, she may scrape and lift out colors from the paper with any handy tool. At times, as in the example at right, some of the colors seep into the damp paper, resembling watercolor washes. When such effects occur, the artist assesses them and develops whatever they suggest with dry or damp brushes; she may even accent an area with watercolor paints.

181

CHALK PASTELS

▇▇▇▇ WORKING WITH POWDERED CHARCOAL

Akin to soft pastels and dry pigments is powdered charcoal, which lends itself especially well to creating some very interesting effects, as the four examples on this page illustrate. In example A, I scattered some powdered charcoal on a piece of smooth watercolor paper, then poured water on it. The result was a very organic look. For B, I scattered charcoal randomly over the paper, then sprayed rather than poured clear water on it. Note that the charcoal has a much finer granulated look. I then used a charcoal pencil to suggest trees. Example C illustrates how to reserve areas of the paper where you do not want the charcoal to go. Simply brush the selected passages with clean water before applying the charcoal, as I did here to establish the flower shape on a piece of gray-green pastel paper. In example D, I sifted the powdered charcoal onto my paper through a fine tea strainer, a method that prevents too heavy a buildup of charcoal. I sprayed the surface with clean water to disperse the charcoal and, when it was dry, lifted some of the dark color with a kneaded eraser to define a few tree trunks. Finally, I sprayed all four examples with workable fixative.

A. Water was poured onto the powdered charcoal for washlike effects.

B. Water was sprayed onto the charcoal for a granular result, and trees were drawn with a charcoal pencil.

C. Water brushed on in a flower shape before charcoal was applied acted as a resist.

D. Charcoal was sifted onto the paper with a tea strainer and tree trunks defined with a kneaded eraser.

■ COMBINING CHARCOAL AND ACRYLIC WASHES

Watercolor, acrylics, colored pencils, and inks can all be used on top of charcoal washes, provided you apply a fixative to the charcoal first. In this example I did the opposite, washing on some acrylic paint first. I applied the charcoal only after the acrylic had dried, and in this case, hosed off the excess powder. These kinds of washes give you different results every time, although with a little practice you can gain some control over how they behave.

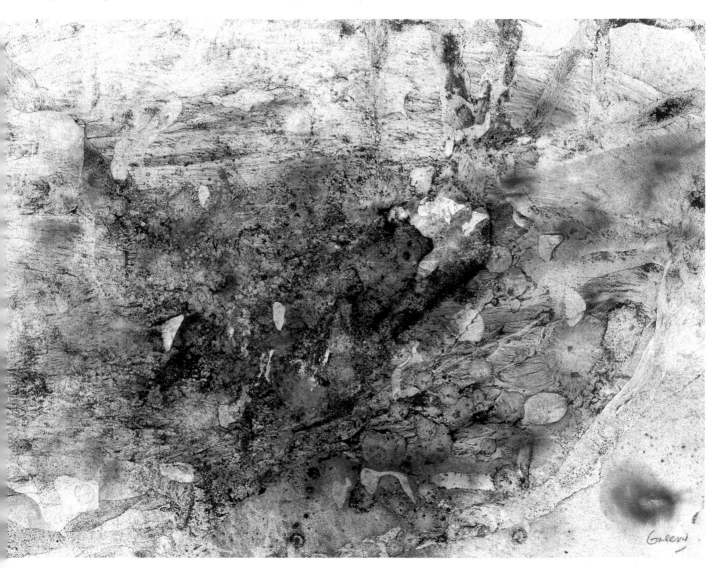

DEMONSTRATION: CHALK PASTELS

▬▬ TONED WITH CHARCOAL

Brian Simmonds takes full advantage of the affinity between chalk pastels and willow charcoal. Here, he uses Canson Montval Aquarelle paper, Rembrandt pastels, a kneaded eraser, a plastic eraser (which he keeps sharpened for detail work), and fixative. This demonstration consists of four stages, beginning with a general color scheme, followed by two stages of toning; details are added in the final stage.

Using only yellow ochre and burnt sienna at this stage, Simmonds quickly and very broadly applies big patches of color in the general locations of the forms in his composition. With a folded piece of paper towel, he lightly rubs the pastel into the paper until saturation is achieved, but at the same time he leaves some of the powder on the surface to aid blending. Applied in this fashion and diluted by the whiteness of the paper, the strong, rich pastel color has the glow of watercolor.

Next comes the first toning stage, in which Simmonds establishes his dark and middle values. For this he uses willow charcoal, which blends beautifully with the pastel pigment, neutralizing the colors and helping to define forms.

In the second stage of toning, the artist uses an eraser to further develop forms and adjust and balance colors and values. He also establishes some details at this time by "drawing" with the eraser. Note how the charcoal has turned the yellow pastel to a green. At this stage, Simmonds applies a couple of light coats of fixative.

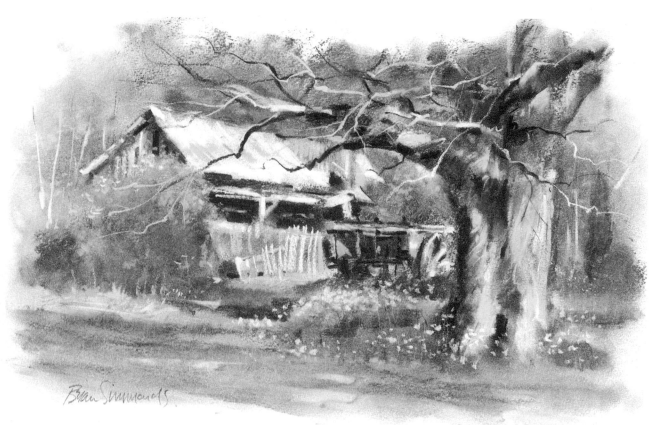

Brian Simmonds, *Backyard, Hahndorf, South Australia,* pastel and charcoal on paper, 15 × 21" (38.1 × 53.3 cm).

In this, the final stage, the artist enlarges the painting's color range with the addition of some light hues, which he applies in places where he had previously created light tones with the eraser. This adds surface texture to the thinly applied, almost transparent colors and tones produced so far. Finally, he adds highlights and sharpens details where needed, refining the features of his composition.

CHALK PASTELS

▬▬ *INCORPORATING ASH WITH PASTEL*

Tony Windberg's painting *Fire and Water,* inspired by the aftermath of a brushfire in southwest Western Australia, incorporates ash from the area, forming a very intimate link with the subject. The artist mixed ash with acrylic modeling paste and applied it with a painting knife to his paper, which was mounted on a firm support. He varied the consistency of the mixture according to the effect he was after; a lower proportion of ash to modeling paste allowed for a thin, translucent application that he scraped back to reveal the paper, while a higher ash content allowed for a thick, textured application that he manipulated in various ways, including drawing into the compound with a pointed object. After letting the ash mixture dry, Windberg worked pastels and charcoal into the painting to add color, tonal definition, and detail.

Tony Windberg,
Fire and Water,
ash and pastel on
paper, 21 × 29
(53.3 × 73.7 cm).

Detail, *Fire and Water.*

Detail, *Fire and Water.*

Dr. Drewfus Gates, *Mountains at Bursa (Turkey),* pastel and acrylic with collage on paper, 20 × 28" (50.8 × 71.1 cm).

■■■■ TEXTURING GROUNDS WITH TISSUE

Dr. Drewfus Gates began these two paintings by preparing interesting grounds to work on. Using a creamy mixture of water and acrylic gesso, he glued acid-free tissue paper to museum board, crumpling and crinkling the paper to create appropriate textures and then applying the gesso mixture over the tissue to fix it in place. With this technique, it is possible to create additional textures by brushing the surface with a stiff brush or sponging on some undiluted gesso. To create small, texture-free areas within a larger textured field—such as the posters on the wall in *The Conversation*—Gates glued on thin drawing paper. Once the final surface texture has been established, it can be stained with acrylic color. As he applied pastel, Gates used grazing side strokes to enhance the texture in some areas and brushed or smudged color in other areas where he wanted to deemphasize texture.

Dr. Drewfus Gates, *The Conversation (Akka-Israel),* pastel and acrylic with collage on paper, 20 × 28 (50.8 × 71.1 cm).

CHALK PASTELS

▆▆▆ STENCILING

Stencils are an interesting way to work with pastels.
In the example at right, I first rubbed some powder
from a broken pastel onto my paper. I then placed
a stencil in the shape of a bird over it and, with a
kneaded eraser, removed color to define the bird's
form. Last, I sprayed the work with fixative.

▆▆▆ ESTABLISHING DARK VALUES WITH INDIA INK

Sometimes when you require a dark background to
offset lighter values, it is easiest and most effective
to define the darks with India ink first and apply
the pastel over the ink. This way the lights and
highlights are kept bright and do not sink into the
background. This is the approach Irene Osborne
took in painting the lizard shown below; note how
well the animal's markings stand out against its
form, which was rendered in India ink.

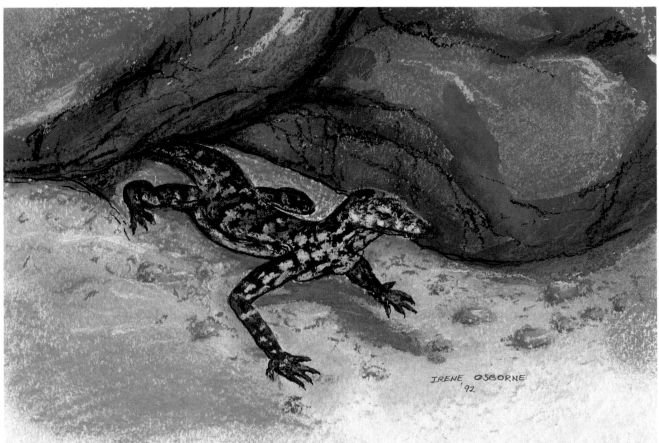

USING PASTEL OVER PENCIL AND WASH

Whatever happened to indelible pencils? I came
across one in the toolshed and decided to use it
with pastel, creating the example at right. I first
made a wash by dipping the pencil in water and
applying it to paper, spreading the color with a wet
brush to paint in the background. While this was
wet, I used the sharp point of the pencil to draw
in the trunk and spikes of the blackboy tree. The
highlights were done with a pastel when all was
dry; I then sprayed the work with fixative.

APPLYING PASTEL OVER ACRYLIC

Irene Osborne laid down the basic shapes of her
composition at left below with acrylic colors, then
applied pastel over this ground, achieving a
vibrant effect.

ACHIEVING TEXTURE WITH MODELING PASTE

To get the lovely effect at right below, I applied
pastel to my paper, then added acrylic modeling
paste with a palette knife, first holding it flat and
then lifting it quickly to create texture. When the
modeling paste was dry, I applied more pastel over
it, then used a fixative.

CHALK PASTELS

▰▰▰ COMBINING PASTELS WITH GOUACHE AND INK

A mottled background created with gouache and ink sets off the subject of Madeleine Clear's painting beautifully. Clear began by stretching a piece of 130-lb. (280 gsm) Rives watercolor paper. Onto its dry surface she dribbled and sprinkled ink and gouache using a variety of colors: crimson, yellow ochre, ultramarine blue, light gold, and sepia. She dabbed the surface, let it dry, then added more ink and gouache until she got an effect that was to her liking. Clear let this underpainting dictate the way she imposed the image of her subject, using charcoal to draw lines and soft pastels to make different kinds of marks. To get a good idea of how she built up the interesting background for the finished painting shown on this page, note the study on the facing page, which was done as a demonstration.

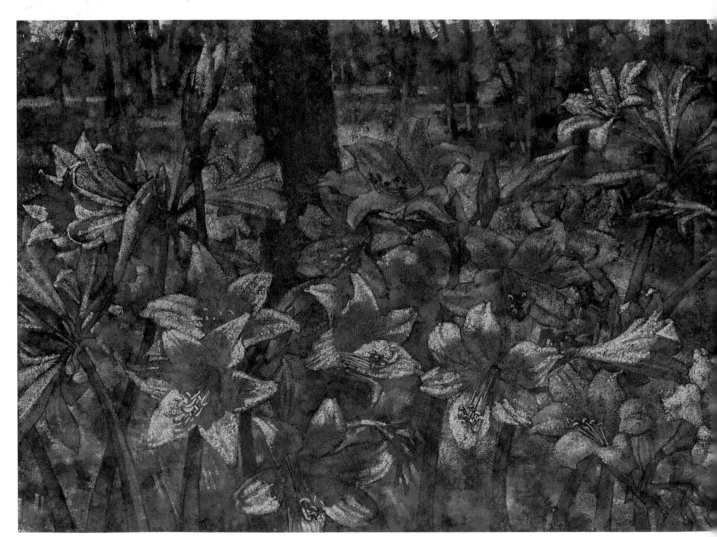

Madeleine Clear, *Grandma's Pink Lilies,* pastel, charcoal, gouache, and ink on paper, 22 × 30 (55.9 × 76.2 cm).

Study for *Grandma's Pink Lilies*.

OIL PASTELS

Oil pastels are the dust-free, oil-soluble, water-resistant cousins of chalk pastels. They are quick to use, conveniently portable, work as both a drawing and a painting medium, and can be combined with oil painting mediums for some special effects. Used with imagination, oil pastels offer many exciting possibilities.

■■■■ COMBINING DIFFERENT APPLICATION METHODS

Judith Dinham developed this interesting monochrome tonal work on cold-pressed rag paper using basically three methods of application. To build up the dense surface of the mountains, she worked the oil pastels firmly into the paper, placing one layer on top of another. In the top layers, the directions of the marks become more important because they describe the form of the mountains. In other areas, the oil pastels have been worked more lightly and sparingly over the paper so that they catch only the "hills" of its moderately rough surface, allowing the white "valleys" to show through, creating a lively sparkle. This textured effect can be seen in the water, in the snow on the far mountain, and in the foreground section of the mountain at right. In the third major method of application, Dinham brushed turpentine sparingly over lightly crayoned areas where she desired a painterly effect; then, once the paper was dry, she drew back into the surface with oil pastels. This method was used in particular for the water and the far mountains. Other, minor methods for applying and working with oil pastels were used as well, including scratching back into and dragging a blade through color passages.

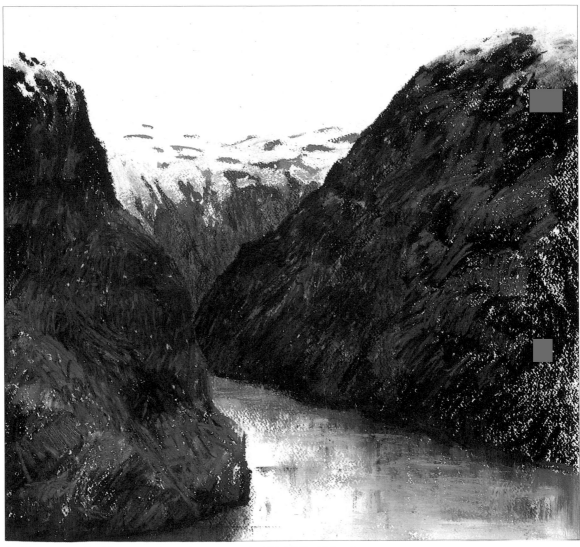

Judith Dinham, *Fiord Summer,* oil pastel on paper, 16 × 17" (40.6 × 43.2 cm).

▬▬ WORKING ON DARK PAPER

In this example I used black pastel paper to make the white of the daisies stand out. I applied white oil pastel quite thickly, and then, using a brush loaded with turpentine, I began to smooth out some of the flowers' petals. I defined their centers and stems the same way. The end result is one of very dramatic contrast.

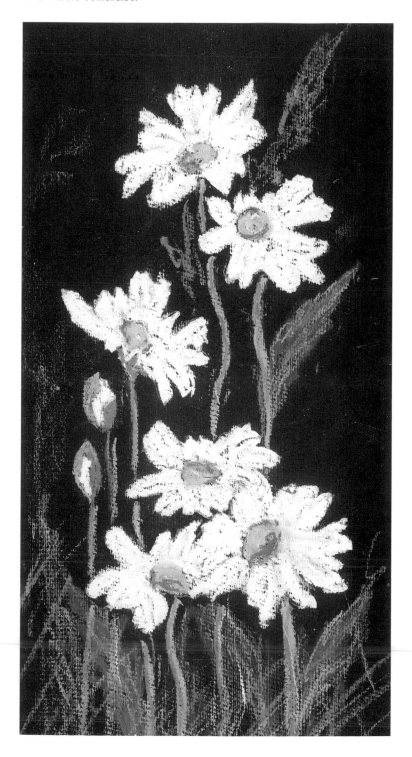

OIL PASTELS

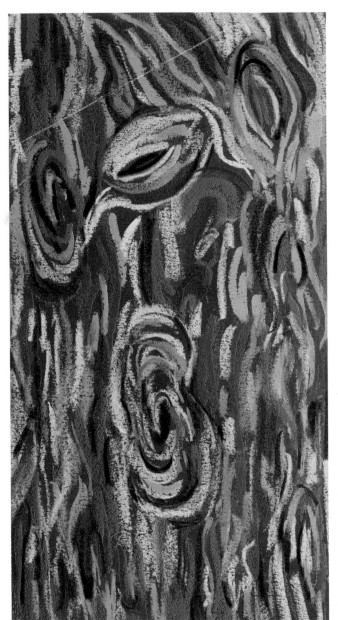

■ PATTERNING WITH LINEAR STROKES

Using a piece of tree bark as a reference, I studied and then copied its pattern in oil pastel to create the example at left. I worked on bright red pastel paper and used lots of different colors, which I applied in an essentially linear fashion. The result is this interesting, almost vibrating effect.

■ GETTING WASH EFFECTS WITH TURPENTINE

Like oil paints and oil sticks, oil pastels are soluble in turpentine, meaning that you can easily create wash effects. In the two examples shown below, in which I paired complementary colors, I rubbed a blue oil pastel lightly across a piece of orange Canson Mi-Teintes pastel paper and a green oil pastel over a piece of red paper. The sparkling effect is caused by the pastel hitting the "hills" of the paper's texture. Then, with a brush dipped in turpentine, I washed over half of the oil pastel, creating a smooth effect.

◼◼ ADDING SUBTLE SGRAFFITO EFFECTS

Here, I began by covering a sheet of blue Canson Mi-Teintes pastel paper with turquoise and green pastel to represent water. I then drew in the fish, allowing some of the underlying water color to show through. To give a textured effect, I used a plastic picnic fork to scrape a subtle pattern of straight lines over the entire surface. (Wavy lines would also be interesting.) The plastic fork was relatively kind to the paper; a sharper or heavier tool might have damaged it.

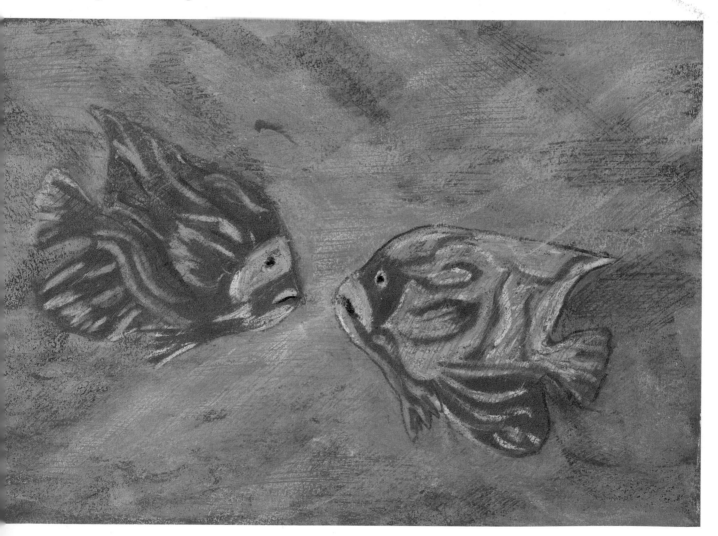

OIL PASTELS

▬ SCRAPING BACK

To illustrate the scraping back technique (right), I randomly applied red, yellow, green, and purple oil pastels to smooth paper, then covered over these colors completely with black oil pastel. Holding a single-edged razor blade against the paper's surface, I scraped tree shapes out of the black oil pastel layer to reveal the colors underneath.

▬ CREATING NIGHTTIME EFFECTS

With silver oil pastel you can create some quite interesting nighttime effects. In the very simple example shown below, I used it to establish the shapes of the buildings first. Next, I covered the silver oil pastel with purple, followed by black. Then, to indicate the buildings' windows, I employ the scraping back technique, dragging a plastic picnic fork (which makes it easy to draw four lines at once) crossways and down to reveal the silver oil pastel underneath the darker layers. (If these lines look too regular, you can rub oil pastel into parts of the surface.)

CRUMPLING PAPER FOR TEXTURE

For the example at left, I rubbed a piece of white paper vigorously with several oil pastel colors, crumpled the paper into a tight ball, then flattened it out. Next, I applied India ink to the surface with a brush. When the ink was almost dry, I washed it off under the tap. The ink that remained created an interesting spider web effect.

COMBINING FOOD COLORING AND OIL PASTEL

Laura Cole achieved the interesting effect shown below by pairing concentrated food dye (professional food coloring) and oil pastels. She laid down vertical strokes of oil pastel, then washed over them with horizontal strokes of dye. This caused the pastel color to break up and take on a shimmering quality.

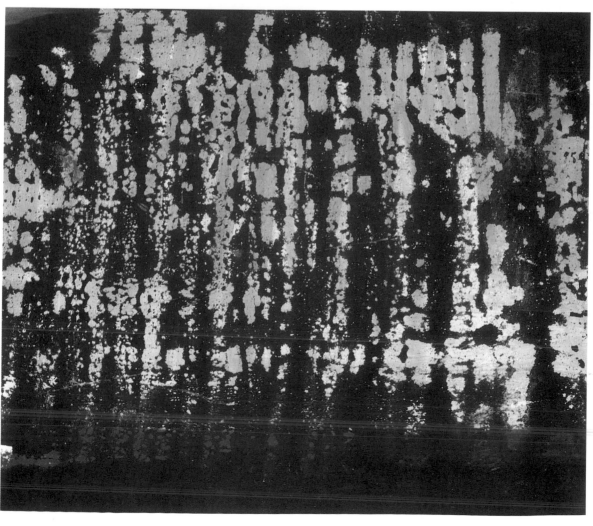

OIL PASTELS

■■■ SCUMBLING OVER TEXTURED ACRYLIC PAINT

To get an interestingly textured ground (right), I spread some white acrylic paint on my paper, then rolled over it with sponge roller. When the paint was dry, I scumbled oil pastel over it and got a lively, sparkling effect because of the way the color clung to the little "hills" of the paint's texture and left the "valleys" white.

■■■ WORKING ON A WARM SURFACE

For the example shown below, I used an electric frypan to warm my paper before applying oil pastel to it. The heat melts the oil pastel while you are drawing, making it slide onto the paper's surface in a very painterly way. It also enables you to rub the drawing with your fingers to get a smooth effect. Do not let the frypan get too hot, as it can scorch your paper.

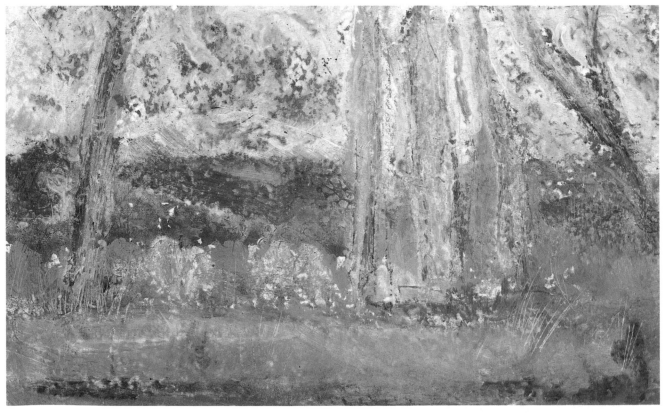

ENHANCING COLLAGE WORK WITH OIL PASTELS

The collage at left by Heather Jones clearly illustrates the particular strengths oil pastels bring to mixed-media work. The artist began her composition by drawing the figure lightly with pencil on Stonehenge printmaking paper, a surface that lends itself well to the technique and mediums used here. Once her figure drawing was in place, Jones isolated it with a paper mask, then proceeded to apply blue-violet oil-based printing ink with a roller to selected areas of the painting. Onto other areas she collaged torn pieces of various textured papers, including some Japanese handmade papers. Next, she added some line work and picked out parts of the figure with India ink. Finally, Jones pulled all of these diverse elements together with oil pastels, adding subtle graphic touches of color to link the collaged, inked, and drawn passages into a harmonious whole.

Heather Jones, *Nude,* mixed media on paper, 22 × 25"
(55.9 × 63.5 cm).

MONOPRINTING WITH OIL PASTELS

It should come as no surprise that, like most of the other mediums discussed in this book, oil pastels, too, can be used quite successfully to make monoprints. For this example, I prepared a piece of watercolor paper with a coat of acrylic gesso to prevent oil from the pastels and painting mediums from penetrating and eventually rotting it. I then spread some Oleopasto (an impasto medium used with oil paints) mixed with turpentine on a sheet of glass (acetate also works) and rubbed several colors of oil pastel into this mixture, dissolving them slightly. I placed the gessoed paper on top of the oil color and rubbed the back of it with my hand, then pulled it off the glass to get this print. Such monoprints make good springboards for paintings.

OIL PASTELS

▬▬ USING OIL PASTELS WITH GOUACHE

In creating this collage, Patricia Goff took advantage of the graphic and texturing abilities of oil pastels. Working on dampened printmaking paper, she began by establishing the basic elements of her composition—sky, rocks, middle ground, and foreground—with washes of gouache, letting the colors flow freely and bleed into one another and ignoring details at this stage. When the washes were dry, Goff collaged on torn and cut pieces of paper she had previously painted with gouache, sticking them down in appropriate places to build up the image. She then placed weights over the collage and left it to dry. Subsequently, the artist developed the character of the sky, the ruggedness and rough texture of the overhanging rocks, the foreground details, and the overall compositional rhythms with oil pastels, using them as drawing tools as well as for building up layers of color and texture. In some areas she scratched back into the layers to reveal underlayers of both oil pastel and gouache color, and in other areas she rubbed the pastel with her fingers to create smooth passages. An oil drawing stick was also used in places to delineate certain shapes. Finally, Goff applied a little white acrylic paint over the blue sky using her finger.

Patricia Goff, *Simpson's Gap*, gouache, collage, and oil pastel on Velin BFK Rives paper, 31 × 8" (78.7 × 20.3 cm).

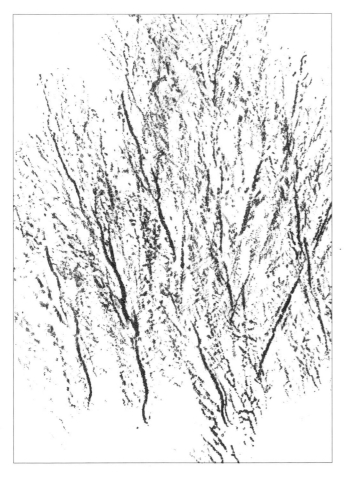

EXPERIMENTING WITH FROTTAGE

Frottage is a technique in which you take an impression of a textured surface by covering it with a sheet of paper and rubbing the paper with a soft drawing medium. In the example at left, I placed Japanese Washi paper over a piece of dried seaweed and rubbed over it with a black oil pastel. This picked up not only the image of the seaweed but also the fibrous texture of the paper.

EXPLORING THE LANDSCAPE WITH FROTTAGE

In the northwestern region of Western Australia, contrasts abound—the beauty of aboriginal sacred sites with the devastation of abandoned mine sites; bright red earth with shimmering purple salt lakes—yet a sense of harmony prevails. To explore this landscape, Glen Hughes employs frottage, taking rubbings of rocks and trees on linen paper. She also collects natural ochres, leaves, arrowheads, stones, and old machine parts. Exploration continues back in the studio, where she examines her findings. The rubbings taken in the field "transport" her back to the desert and beyond, leading her to develop the images further with oil pastels until landscapes like this one emerge naturally.

Glen Hughes,
Natural Order, oil
pastel on paper,
18 × 20"
(45.7 × 50.8 cm).

OIL PASTELS

CREATING TEXTURE WITH SAND

One of my favorite surfaces to work on is one that has been textured with sand. For the example at right, I first applied acrylic matte medium to my watercolor paper where I wanted the sand to appear. While the matte medium was still wet, I sprinkled some red desert sand onto it and left it to dry. Then I scumbled over the sand with oil pastel, creating this lovely broken color effect.

WORKING WITH METALLIC COLORS

Metallic pigments look especially dramatic against a black or very dark background, as the examples below illustrate. To take full advantage of this effect, I heated black paper in an electric frypan, then applied bronze, silver, and copper oil pastels to the warm surface, where the color melted and spread. When it had cooled, I scratched back into the pastel with a compass point to create some graphic interest.

■ COMBINING INK WITH IRIDESCENT OIL PASTEL

In addition to metallic colors, oil pastels come in several lovely iridescent hues that can add luster and excitement to your work. One effective way to use them is illustrated by the example at left. I applied pink, blue, and yellow iridescent oil pastels to a piece of watercolor paper, which I then washed over with blue-green ink. The oil color resisted the ink, which beaded up in places to create a mottled pattern. The matte ink seems the perfect foil for the lustrous pastel color.

■ DRAWING ON AN INK-WASHED BACKGROUND

Applying oil pastel over a background colored with ink can yield some very interesting and subtle results. Below, I covered watercolor paper with an ink wash, and just as the shine was leaving the surface, I dropped in some salt to add texture. When all was dry, I defined the shell with oil pastel and scumbled over the background to create an underwater effect.

OIL PASTELS

▰▰▰ IRONING COLOR INTO PAPER

Using a razor blade, I scraped sticks of oil pastel to deposit color on a piece of watercolor paper. I then placed a second piece of paper over the color deposited on the first and pressed it with a hot iron. This gave me the mirror images A and B. I then placed a piece of watercolor paper over example A and pressed it with the hot iron, resulting in example C. Note how much less color was transferred in this second printing.

A.

▰▰▰ MELDING COLOR WITH OLEOPASTO

To create the representation of an opal shown at the bottom of the page, I began by applying various oil pastel colors to smooth black paper. I then squeezed out a small amount of Oleopasto and rubbed it lightly into the surface with my finger. This melded the colors and gave the work a smooth sheen.

B.

C.

▬▬▬ *MELTING COLOR WITH A CANDLE*

This landscape is a good example of how to juxtapose smooth and rough textures effectively. I began by applying oil pastels to my canvas in a broad manner, then washed over the color with turpentine to smooth it out. Next, I lit a candle and carefully held a stick of oil pastel over the flame to soften it. Working quickly, I applied the molten color to my painting, where it solidified very quickly. I continued this way with a succession of colors to create the textured flowers in the foreground of my painting. Finally, I defined a few trees and some other details by scratching out color with a scalpel.

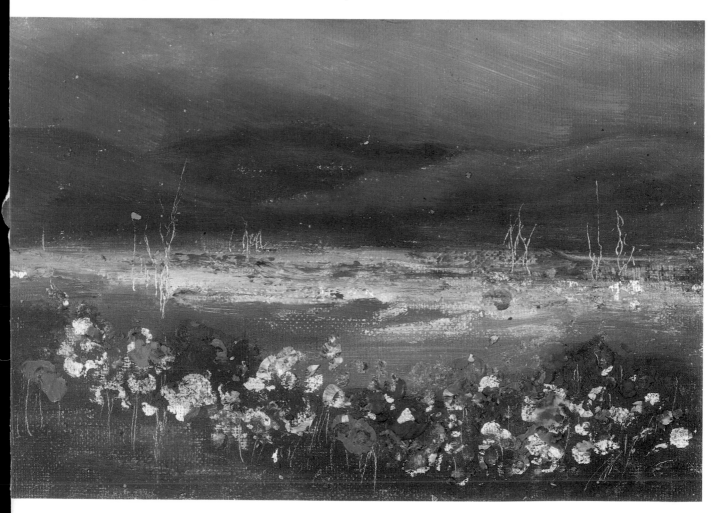

INDEX

AUTHOR'S NOTE

Many times have we heard that there is nothing new in art; perhaps that is basically true. With more than forty artists contributing to this book, however, all with individual thoughts, creative energies, and unique experiences, new directions should have emerged and different perspectives been established.

It is my humble wish that every reader of this book will gain increased enthusiasm for artistic exploration and experimentation. In that spirit, I invite you to write to me with your comments on the techniques presented here, and to share your ideas on different approaches to the various mediums that you feel may be of interest to other readers in the future. Address comments to:

Jean Drysdale Green
32 Regent Street West
Mount Lawley 6050
Western Australia

May your creative efforts be amply rewarded.